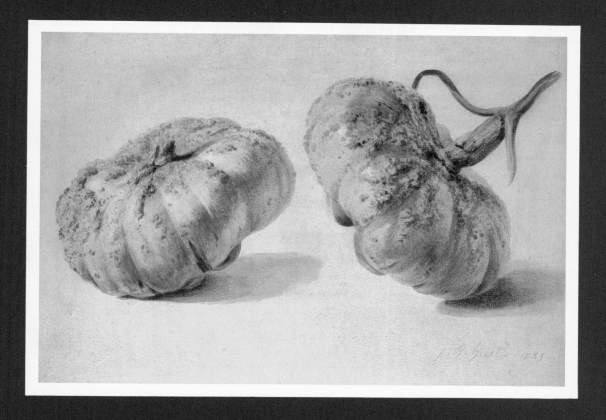

EIGHTEENTH CENTURY
MASTER DRAWINGS
FROM THE ASHMOLEAN

EIGHTEENTH CENTURY
MASTER DRAWINGS
FROM THE ASHMOLEAN

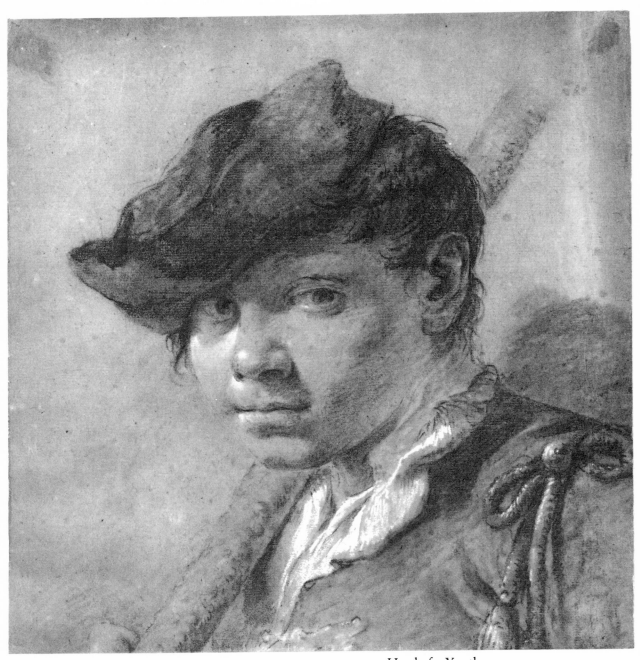

16. GIOVANNI BATTISTA PIAZZETTA: Head of a Youth

EIGHTEENTH CENTURY MASTER DRAWINGS FROM THE ASHMOLEAN

INTRODUCTION AND CATALOGUE

BY KENNETH J. GARLICK

ORGANIZED AND CIRCULATED BY THE

International Exhibitions Foundation

1979–1980

Participating Museums

BALTIMORE MUSEUM OF ART
BALTIMORE · MARYLAND

THE MINNEAPOLIS INSTITUTE OF ARTS
MINNEAPOLIS · MINNESOTA

KIMBELL ART MUSEUM
FORT WORTH · TEXAS

CINCINNATI ART MUSEUM
CINCINNATI · OHIO

COPYRIGHT © 1979 BY THE INTERNATIONAL EXHIBITIONS FOUNDATION
LIBRARY OF CONGRESS CATALOGUE CARD NO. 79–88764
ISBN: 0–88397–008–2
PRODUCED BY THE MERIDEN GRAVURE COMPANY AND THE STINEHOUR PRESS
Cover Illustration: Cat. No. 77. Jean-Baptiste Huet, *Two Studies of a Pumpkin*

Acknowledgments

IN KEEPING with a long-established tradition of specializing in exhibitions of Old Master Drawings, the International Exhibitions Foundation is proud to present this selection of eighteenth century drawings from the Ashmolean Museum, Oxford.

The eighty-nine works exhibited here represent some of the finest examples from this distinguished collection, and we are extremely grateful to the Visitors of the Museum and to its Director, David Piper, for so generously agreeing to lend these treasures for a tour of four American museums.

The exhibition would not have been possible without the efforts of Mr. Kenneth Garlick, Keeper of Western Art at the Ashmolean, who has worked with us for several years on this project. In addition to selecting the drawings and writing the catalogue, Mr. Garlick has given us enthusiastic cooperation and valuable advice at every stage, and we are deeply in his debt.

Special thanks are due the British Ambassador, Sir Nicholas Henderson, who has graciously agreed to serve as honorary patron of the exhibition during its American tour. We also wish to express our gratitude to Mr. Hugh Crooke, Cultural Attaché at the British Embassy, for his interest throughout the organization of the exhibition.

We are pleased to acknowledge those organizations which have rendered financial assistance to the project. The National Endowment for the Arts, Washington, D.C., a Federal agency, has provided a generous grant toward both the exhibition and the catalogue. The catalogue also is underwritten in part by funds from The Andrew W. Mellon Foundation, for whose support we are sincerely grateful.

Our warm appreciation goes to Mr. William J. Glick of The Meriden Gravure Company and to Mr. C. Freeman Keith of The Stinehour Press, who once again have collaborated to produce another fine catalogue for us. We also wish to thank Caroline Davidson and Taffy Swandby for their editorial

assistance. Finally, special mention is due to the Foundation staff, and in particular Crystal Sammons and Heidi von Kann, for attending to the many practical details involved in preparing the exhibition for tour.

<div align="right">

ANNEMARIE H. POPE
President
International Exhibitions Foundation

</div>

Introduction

THE BUILDING UP OF the collections of a great museum may seem to an outsider to be a planned exercise carried out over a calculated number of years. It is, however, much more usually a matter of chance and luck. There are times when an acquisition policy may be logically pursued because there are funds in hand and the prospect for the immediate future seems to be assured. There are other times when the funds suddenly dry up or are curtailed. Sometimes a gift or bequest of dazzling quality so alters the nature of a collection that the policy, if there is one, has to be changed or abandoned. There is, in any case, a limit to what can be achieved by policy. What matters is adaptability, personality and flair. This is particularly the case with a museum like the Ashmolean which is a department of an ancient University. The first colleges of the University of Oxford were founded in the thirteenth century, and new ones are still being established today. Museums are comparative newcomers to the Oxford scene but the Ashmolean, the first of them, is already on the way to being venerable. It will celebrate its tercentenary in 1983. It was indeed not only the first museum in the University of Oxford but the first in Great Britain—and possibly also the first in Europe—to be open to the public. Now it is an institution of international importance but, happily, it remains at the same time basically private in character and personal to the University. The fact that it has developed slowly and, to begin with, parochially, has resulted in a great collection that manages not to be overpowering. The rooms are comparatively small and there is an atmosphere of intimacy and pride of possession, an atmosphere which the University perhaps takes too much for granted but which the hundreds of visitors who come to the museum from outside Oxford understand, appreciate and enjoy. It is an ethos which has attracted wonderful gifts, not only from old Oxonians who have known the Ashmolean since their undergraduate days and love it, just as they love Oxford, but also from many who did not study here but who feel that this

museum will provide a sympathetic permanent home for the treasures they have personally collected.

The Ashmolean is now almost a miniature British Museum and Victoria and Albert Museum in one. It has splendid collections of paintings and drawings, of archaeological discoveries, of classical sculpture, of oriental ceramics and of coins. How does it come about that it also houses one of the great Print Rooms of the world? A matter of chance again. Sir Thomas Lawrence, the portrait painter, who died in 1830 at the age of sixty, had collected old master drawings throughout his forty years of working life, and at his death the collection was one of the finest, perhaps *the* finest, that has ever been brought together by one person. He had hoped that after his death it might be kept intact but the times were against it, and during the following twenty years the drawings were gradually dispersed. Through the efforts of a small number of people working against great odds, and with good luck in the form of a generous gift of money from the young Earl of Eldon, an important part of Lawrence's collection of drawings by Michaelangelo and Raphael was purchased for the University of Oxford in 1845–46. The negotiations were protracted and complex. They are related by Sir Karl Parker in the introduction to his *Catalogue of the Collection of Drawings in the Ashmolean Museum, Vol. II, Italian Schools* (1956) and in greater detail by Mr. Denys Sutton in his introduction to the catalogue of the exhibition *Italian Drawings from the Ashmolean Museum*, held by Messrs. Wildenstein, New York, in 1970. One good thing often leads to another, and it was no doubt as a result of the decision of the University to acquire this portion of the Lawrence Collection that in 1855 Mr. Chambers Hall decided to hand over to it his own very choice collection of drawings and paintings. No doubt he was also influenced by the fact that the new University Galleries (the present Ashmolean Museum) had recently been completed. Chambers Hall was not a specialist. He was a man of independent taste and judgement, himself a painter, who recognized quality instinctively. His predilection was for the seventeenth and eighteenth centuries. Five drawings from his gift are included in this exhibition, notably the Watteau *Two Musicians* (no. 86) and the splendid Guardi *Palazzo Contarini del Zaffo* (no. 9).

Oxford already possessed one collection of old master drawings before it

acquired the Michaelangelos and Raphaels. This had come in 1834 in the form of a bequest from the antiquarian Francis Douce, but as at that time there were no University Galleries to house it, it had been allotted to the Bodleian Library.

Elias Ashmole's original gift to the University in 1683 had consisted largely of curiosities or "rarities," and to house them a fine building was immediately set up adjacent to the Sheldonian Theatre in Broad Street. There Ashmole's gift remained for many years, but in the nineteenth century it was realized that if the collection was ever to grow in importance and scope a new and larger building must be found; and so the University Galleries mentioned above, of a fine neo-classical design by C. R. Cockerell, came into being. The splendor of this building and the quick growth of the collections within it were effective in persuading the Curators of the Bodleian to deposit the greater part of the Douce collection there in 1863, and with this transfer the University possessed in Lawrence, Chambers Hall and Douce, the nucleus of a great collection of old master drawings. Thus also was the nucleus of a Print Room established.

Douce was a very different type of collector from Chambers Hall. He was more interested in the northern European Schools than the southern, and his approach to collecting was antiquarian and historical rather than aesthetic. It was even quirky. The presence in this exhibition of the Ghezzi (no. 5), the Laroon (no. 44), the Rowlandson (no. 49) and the Boitard (no. 61) is evidence of this. Even the Watteau, *Le Naufrage* (no. 87), although a splendid drawing, is unusual, an "illustration" in a sense that Watteau drawings usually are not.

From 1863 when these three collections were assembled together, drawings were acquired from time to time but very largely by gift and accident, and it was not until the appointment of Mr. K. T. Parker (now Sir Karl Parker) as Keeper of Art in 1934 that the development of the Print Room went forward with speed. In 1945 Sir Karl became Keeper of the whole museum. He retired in 1962. During his time the systematic collecting of drawings became the major activity of the Department. It was one of those happy periods when policy really does have a chance to work, for although the available funds were meager in the extreme they were at least steady and Parker realized that the best way of using them was to concentrate on the acquisition of old master drawings. For nearly thirty years he bought constantly at prices that now seem

inconceivable, and persuaded numerous collectors to make benefactions to the Print Room. It was he who gave to the Print Room the importance it has today. Moreover, in his catalogues he set the highest possible standard of scholarship. Of the drawings in the exhibition, thirty-nine were acquired by purchase and of these, thirty were acquired in Parker's time. In almost any exhibition of drawings selected from the Ashmolean Print Room the proportion would be much the same. This in itself is the most positive of tributes to Sir Karl. Of the other drawings in the exhibition that came in by purchase only four were before his time and only five were after it.

Drawings are essentially private things. They are sometimes made as quick notations or working references for future use in something of a more finished nature (nos. 2 and 46) but even so they are often enchanting. Or they may be made as works of art complete in themselves, for contemplation and slow studying rather than amazement (nos. 32 and 36). There is usually a difference between a drawing and a sketch in oils in that the one reveals its message slowly and only at close quarters while the other may dazzle or fascinate from afar. Drawings are to be lingered over, and the experienced collector will say that it is only through studying them over the years that he truly has become a connoisseur and savant. For the average visitor to an exhibition there may seem to be no time at all to become a connoisseur, but if he will linger and not hurry, if he will examine the difference in character of line between one drawing and another, or decide for himself what it is that distinguishes a slow and premeditated drawing from one that is quick and spontaneous, and if he will come to the exhibition again and again, he will find that willy-nilly he is beginning to be a connoisseur in his own way. The desire to become one in a fuller sense will soon possess him. Quality is what counts and everyone has the capacity to train his eye for quality if he is prepared to do so. Nothing can bring greater rewards in enjoyment and instruction.

The eighteenth century is a time to look back to with nostalgia because it was an age of leisure. Time passed relatively slowly for everyone. The industrial revolution had scarcely begun its terrible progress of visual havoc and human misery. The countryside everywhere was unspoiled. New buildings were dignified. There was plenty of space and not too many people. Canaletto could make a careful record of an island in the Venetian lagoon (no. 1) or

Watteau a delicate impression of the face of a boy in profile (no. 88). From the standpoint of today they had all the time in the world to do these things. This is not to say that in the two succeeding centuries all this has been lost, but it is now much more difficult for the artist to be left alone, to get away, to live simply or to lose all sense of time. The eighteenth century was in retrospect wonderfully, and of course unselfconsciously, civilized in the simple as well as the sophisticated meaning of that word. I hope that this exhibition in its juxtaposition of simple with elaborate drawings, will help to draw the visitor back into the period.

It is a great pleasure to the staff of the Department of Western Art of the Ashmolean Museum that the exhibition will travel to the United States of America.

KENNETH GARLICK

Author's Acknowledgments

THE ENTRIES in the catalogue for drawings already included in K. T. Parker's catalogues of the French and Italian drawings in the Ashmolean Museum are based upon the entries in those books, and for fuller information the reader is referred to them. In a very few cases further details of history, etc. have come to light since Parker's volumes were published.

I am deeply grateful to Mr. Hugh Macandrew, Keeper of the National Gallery of Scotland, who has completed a supplement to Parker's catalogue of Italian drawings, and to Dr. David Brown, Departmental Assistant in charge of the Ashmolean Print Room, who is working on a catalogue of the English seventeenth and eighteenth century drawings, who have both allowed me to make full use of their as yet unpublished material. In particular I thank Mr. Macandrew for access to his entries for nos. 6, 7, 11, 12 and 25, and Dr. Brown for access to his entries for nos. 31, 35, 37, 39 and 54.

Catalogue

Note on the Catalogue

References to the appropriate literature are given in full wherever possible, with the exception of the two catalogues by Sir Karl Parker, which are recorded simply as "Parker I" and "Parker II." Volume I, published in 1938, catalogues the drawings of the Netherlandish, German, French and Spanish Schools. Volume II, published in 1956 (reprinted in paperback in 1972), catalogues the drawings of the Italian Schools. A Supplement to Volume II has been prepared by Mr. Hugh Macandrew, Keeper of the National Gallery of Scotland, and is now with the press.

Italian

Antonio Canal, called Canaletto
1697–1768

1 AN ISLAND IN THE VENETIAN LAGOON

Pen and brown ink with grey wash over ruled pencil lines and a little pin-pointing. The design is enclosed within a ruled border-line of black ink.

7⁷/₈×10¹⁵/₁₆ in. (20×27.9 cm.)

Collections: Otto Gutekunst; presented by Mrs. Otto Gutekunst in memory of her husband, 1947.

Exhibitions: Venice, Cini Foundation, *Disegni veneti di Oxford*, 1958 (85); Toronto–Ottawa–Montreal, *Canaletto*, 1964–65 (100); New York, Wildenstein, *Italian Drawings from the Ashmolean Museum, Oxford*, 1970 (67).

Literature: D. von Hadeln, *Drawings of Antonio Canal* (1920) p. 14; Parker, II, p. 492, no. 980; W. G. Constable, *Canaletto*, 2nd ed. (1976), I, p. 130, pl. 120, II, p. 537, no. 654.

Sir Francis Watson has pointed out that the drawing probably shows the Island of S. Michele with the Fondamente Nuove in the background. The design was engraved in reverse by Giuseppe Wagner in the series, *Sei Villeggi Campestri*, no. 52.4, published by him in (?) 1742. Various related drawings are listed by Parker and Constable (see above).

2 VENICE: ST. MARK'S AND THE LOGGETTA

Pen and brown ink.

3¹/₂×4¹³/₁₆ in. (8.9×12.2 cm.)

Inscribed by the artist at the upper margin, *Canton dela Lozeta uersso S. Marcho*.

Collections: Chambers Hall, by whom presented to the University Galleries, 1855.

Exhibitions: Toronto–Ottawa–Montreal, *Canaletto*, 1964–65 (115).

Literature: Parker, II, p. 491, no. 979; T. Pignatti, *Canaletto, Disegni* (1969) xvi; W. G. Constable, *Canaletto*, 2nd ed. (1976), II, p. 452, no. 554, pl. 101.

Possibly a page detached from a small sketchbook. Dated by Parker and Pignatti after 1730 and before 1740. On the back a rough jotting of a recipe in Canaletto's handwriting, *Oio di Cera non veti/ticà. et grasso / uman. drame due per Sorte.* There is also a mutilated inscription *alti piedi 2¹/₂ Inglesi, e longhi [. . .]* which suggests that the sheet must have been slightly clipped at both sides.

Paolo dei Matteis
1662–1728

3 THE TRIUMPH OF GALATEA

Black chalk with brown and grey washes.

5¹/₈×7¹/₂ in. (13×19.1 cm.)

Collections: Anonymous, Christie's sale, 27 November 1973 (290) *repr. cat.*; Miss Yvonne ffrench; purchased 1974.

On the *verso* is a male portrait head in black chalk inscribed in brown ink in a contemporary hand, *Ritratto di Paolo de Matteis* and an outline sketch in brown ink of the coastline from Salerno to Naples.

Gaetano Gandolfi
1734–1802

4 STUDY OF A MALE NUDE

Black chalk, stumped, with some grey wash and red chalk on a pale buff paper.

16³/₁₆×12¹/₄ in. (41.2×31.2 cm.)

Collections: E. Shapiro; Mrs. E. Borstrom; purchased in 1963.

When published in the Ashmolean Museum *Report* 1963, no. 4 was attributed to Gaetano Gandolfi's elder brother, Ubaldo. The style and vivacity of the drawing are, however, more typical of Gaetano.

Pier Leone Ghezzi
1674–1755

5 A GENTLEMAN AND HIS TWO SERVANTS
Pen and dark brown ink.
11 19/32 × 10 1/4 in. (29.5 × 25.8 cm.)
Inscribed in ink of a different color from the drawing, *Ghezzi in Roma 1727*.
Collections: Francis Douce, by whom bequeathed to the Bodleian Library, 1834; transferred to the Ashmolean Museum, 1863.
Literature: Parker, II, p. 503, no. 1003.

6 CONTESSA FALSACAPPA WITH A NUN AND ATTENDANT SERVANT
Pen and sepia ink. The design is enclosed within a double border-line.
9 7/8 × 6 3/4 in. (25.1 × 17 cm.) (Watermark: a bird on three mounts within a circle.)
Collections: Pico Cellini; William H. Milliken, Sotheby's sale, 21 March 1974 (113) *repr. cat.*; Miss Lorna Lowe; purchased 1976.
Exhibitions: Cleveland, Museum of Art, *Fiftieth Anniversary 1919–1969. . . . Prints and Drawings lent by Members of the Print Club*, 1970.

Two related drawings obviously portraying members of the same family were also included in the Milliken sale. One shows two small boys who have written their names on pieces of paper in front of them, *Serafino Falsaca* and *Francesco Falsacap*; from this (and from a label on the back of the old frame) it has been deduced that the subject of the drawing now exhibited represents their mother, and the subject of the third drawing, their grandmother. The whole group may be dated *c.* 1710.

The Falsacappa, nobles of Spoleto, Foligno, Corneto, etc. were a Roman family of long standing.

Antonio Gionima
1697–1733

7 CLEOPATRA DISSOLVING THE PEARL
Red chalk heightened with white; the *verso* in red and black chalks.
Verso: the upper half of a male head in profile to the left.
7 7/8 × 9 13/16 in. (18.9 × 23.9 cm.) The measurements are taken from the longer sides of the irregularly cut paper.
Collections: Sotheby's sale, 10 December 1975 (14); Miss Yvonne ffrench; purchased 1977.

The incident shown in the drawing is recounted by Pliny in his *Natural History* (Book ix, ch. 58). Cleopatra, by dissolving in vinegar one of her two pearls, which were judged to be the largest in history, proves to Anthony her boast that she would spend a fortune upon a single banquet.

Surviving chalk drawings by Gionima are rare—see Catherine Johnston in the catalogue of the Uffizi exhibition, *Disegni Bolognesi*, 1973, p. 102, no. 121.

Francesco Guardi
1713–1793

8 A "BISSONA" WITH A PROTECTIVE AWNING
Pen and brush in brown ink over preliminary indications in black chalk.
5 11/16 × 11 7/8 in. (14.5 × 29.6 cm.)
Purchased in 1937.
Exhibitions: Venice, Cini Foundation, *Di-*

segni veneti di Oxford, 1958 (117); London, Kenwood, Iveagh Bequest, *Life in XVIII Venice*, 1966 (23).
Literature: Parker, II, p. 312, no. 1018; J. Byam Shaw, *The Drawings of Francesco Guardi*, 1951, p. 73, no. 55; A. Morassi, *Tutti i Disegni di Francesco e Giacomo Guardi*, 1975, p. 131, no. 306, fig. 306.

A "bissona" was an eight-oared boat decorated for regattas in Venice. Other representations in drawings and paintings by Guardi are listed by Parker.

9 THE GARDEN OF THE PALAZZO CONTARINI DEL ZAFFO, VENICE

Pen and brush in india ink over black chalk.
$13^{29}/_{32} \times 20$ in. $(35.3 \times 50.8$ cm.)
Collections: (?) Prince Poniatowsky, Christie's sale, 27–30 May 1840 (261), "The Garden of a Palace, penwashed" (2); Chambers Hall, by whom presented, 1855.
Exhibitions: London, Royal Academy, *European Masters of the Eighteenth Century*, 1954–55 (575); Venice, Cini Foundation, *Disegni veneti di Oxford*, 1958 (116); Venice, Palazzo Grassi, *Mostra del Guardi*, 1965 (60); New York, Wildenstein, *Italian Drawings from the Ashmolean Museum*, 1970 (69).
Literature: K. T. Parker, "Some observations on Guardi and Tiepolo" in *Old Master Drawings*, XIII, March 1939, p. 58, pl. 52; Parker, II, p. 509, no. 1014; A. Morassi, *Tutti i Disegni di Francesco e Giacomo Guardi*, 1975, p. 155, no. 419, fig. 422.

Another drawing of the same garden is in the Boymans–van Beuningen Museum, Rotterdam (Koenigs Collection) and a painting corresponding fairly closely with no. 9 was with Knoedler, New York, 1973 (A. Morassi, *Guardi*, 1973, p. 436, no. 680). The Palazzo Contarini del Zaffo still stands, near the Madonna dell'Orto, at the Fondamenta Continari, no. 3539.

Antonio Joli
1700–1777

10 INTERIOR OF A CHURCH WITH FIGURES

Pen and ink (black and brown) with grey wash over pencil. Many of the lines are drawn with the aid of a ruler. Signed *A. Joly fecite*. On the *verso* are various roughly sketched architectural plans.
$15^{11}/_{16} \times 10^{10}/_{32}$ in. $(40 \times 27.$ cm.)
Purchased in 1944.
Exhibitions: Venice, Cini Foundation, *Disegni veneti di Oxford*, 1958 (78).
Literature: Parker, II, p. 513, no. 1020.

Carlo Labruzzi
1748–1817

11 ARCH ON THE ROAD TO CORI

Pencil and watercolor within a double-lined border in sepia.
Painted area: $15^{1}/_{4} \times 21^{1}/_{4}$ in. $(38.5 \times 54$ cm.)
Collections: from a set of watercolors contained in four volumes which were alleged to have been found in a bombed house in London during the Second World War, and perhaps at one time formed part of the stock of W. Palmer, Labruzzi's agent for *Via Appia illustrata* (see below) in London; purchased in 1960.
Exhibitions: London, John Manning, *Fine Watercolour Drawings of the Appian Way*, 1960 (58).
Literature: F. J. B. Watson, *Introduction to catalogue of John Manning's exhibition* (see above).

The set to which no. 11 belongs is a record of Sir Richard Colt Hoare's journey along the Via Appia in 1789 which he described in his *Recollections Abroad during the Years 1788, 1789, 1790*, II, 1815, pp. 259–334, and, later, in *A Classical Tour through Italy and Sicily*, 1819, pp. 57–118. Sir Richard left Rome on 31 October,

accompanied by Labruzzi whom he had engaged to draw the various monuments of classical antiquity along the route. His original intention had been to publish an account of the Via Appia, having travelled its whole length to Brindisi, and although the journey had to be abandoned at Benevento he persisted in the idea of a publication which was to include engravings after Labruzzi's drawings. For this Labruzzi made careful sepia drawings working from the free watercolors— many are now in the Vatican Library—but of the twenty-four plates issued in Hoare's lifetime only the first fascicule of twelve was published (without text) under the title: *Via Appia illustrata ad urbe Roma ad Capuan* (1794). The watercolors which relate to these engravings are in the British Museum.

The sepia drawings were ultimately published by Thomas Ashby in a paper "Dessins inédits de Carlo Labruzzi" in *Mélanges d'Archéologie et d'Histoire*, XXIII, 1903, pp. 375–418, and it was he who identified the subject of the Ashmolean watercolor when discussing the sepia drawing to which it related.

Carlo Marchionni
1702–1786

12 THE FOOT OF A FLIGHT
 OF STAIRS
 Pen and brown ink and brown wash over black chalk.
 7⁴/₅ × 10⁷/₁₀ in. (20 × 27.4 cm.)
 Inscribed by the artist in ink, top right corner: *Incominciamento della Scale scoperta verso La Tribuna di S. Simone et Guda* [*i.e.* of St. Peter's, Rome] *apposta/ nel Arco chiuso per comodo di quella Galle/via per L'esito di esse.*
 Collections: Lord Kinnaird; purchased in 1956.

The drawing relates to the Sacristy of St. Peter's, which was built to Marchionni's design between 1776 and 1784, on the commission of Pope Pius VI. There are numerous drawings by him in the Martin von Wagner Museum, Würzburg, several of which are connected with the elaborate staircase to be erected on the outside of the Sacristy of St. Peter's, and intended to serve as one of its entrances. Marchionni was trained as a sculptor, but developed as an architect and became an influential figure in the circle of Winckelmann.

Pietro Antonio Novelli
1792–1804

13 THE ECSTASY OF
 ST. FRANCIS XAVIER
 Pen and ink with black and grey wash.
 12¹³/₁₆ × 9¹/₂ in. (32.6 × 24.1 cm.)
 Presented by Mr. Karl Parker, 1938.
 Literature: Parker, II, p. 517, no. 1029.

Francesco de Xavier (1506–1552), known as the Apostle of India and Japan, was one of the great Jesuit missionaries. He was canonized in 1621. He died of fever on the island of Chang-chuen-shan, off the coast of China. His emblem is the tongue of flame (depicted in the drawing) symbolizing his love of Christ.

Giovanni Battista Piazzetta
1682–1754

14 NUDE FIGURE OF A
 YOUNG MAN
 Black chalk with stump, heightened with white, on bluish-grey paper.
 21⁷/₈ × 15¹/₂ in. (55.6 × 39.4 cm.)
 Purchased in 1951.
 Exhibitions: Venice, Cini Foundation, *Disegni veneti di Oxford*, 1960 (80).
 Literature: Parker, II, p. 519, no. 1035.

Parker points out that the pose is reminiscent of the woman carrying a child at the extreme left of Tintoretto's *St. Mark rescuing a Slave* in the Accademia, Venice. Similar academic nude studies by Piazzetta were reproduced by R. Pallucchini in *Piazzetta*, 1956, figs. 130, 135–139, and in *Arte Veneta*, XXII, 1968, fig. 187, the latter dated 1748.

15 MEDALLION PORTRAIT OF NICCOLÒ MACHIAVELLI

Black and white chalk on light blue paper.
11⁷/32×8²⁵/32 in. (28.5×22.3 cm.)
Purchased in 1938.
Literature: Parker, II, p. 519, no. 1036.

Probably drawn for a book illustration, the likeness being based on contemporary portraits.

16 HEAD OF A YOUTH

Black and white chalks on brown paper.
12⁹/32×11¹¹/16 in. (31.3×29.8 cm.)
Purchased in 1934.
Exhibitions: Venice, Cini Foundation, *Disegni veneti di Oxford*, 1960 (81); New York, Wildenstein, *Italian Drawings from the Ashmolean Museum, Oxford*, 1970 (63).
Literature: Parker, II, p. 519, no. 1034; R. Pallucchini, *Piazzetta*, 1956, p. 50, fig. 126; A. Pignatti, *La Scuola veneta*, 1970, pl. xxvi, in color.

A drawing (397:320) in the Muzeul de Arta at R. S. Romania, Bucharest (inv. no. 9259), which in the opinion of Professor Michael Jaffé is a good contemporary copy, includes the sitter's hand and completes the tassels on his shoulder, thus suggesting that the Ashmolean drawing has been trimmed along its bottom and right edges.

Giovanni Battista Piranesi
1720–1778

17 STUDY OF A RUINED BUILDING

Brush and pen over black chalk.
9³/8×9¹/2 in. (23.8×23.5 cm.)
Collections: L. H. Philippi, Hamburg; Albertina (Archduke Frederick of Hapsburg); purchased 1942.
Exhibitions: New York, Wildenstein, *Italian Drawings from the Ashmolean Museum*, 1970 (71); Venice, Cini Foundation, *Piranesi–Disegni*, 1978 (78).
Literature: Parker, II, p. 522, no. 1044.

According to Parker this drawing appears to be related to the etchings by Francesco Piranesi (son of Giovanni Battista) published in 1804 under the title *Antiquités de Pompeia*, the title page of which states that the series is based on drawings by his father.

18 AN ARCHITECTURAL FANTASY: INTERIOR OF A BASILICA

Pen and brown ink with brown wash over red chalk.
14²¹/32×20¹/16 in. (37.2×50.9 cm.)
Signed *Piranesi*, on bottom step of stairs at right.
Collections: Earl of Abingdon, Sotheby's sale, 17 July 1935 (17); purchased 1935.
Exhibitions: London, Arts Council, *Piranesi*, 1978 (47); Venice, Cini Foundation, *Piranesi–Disegni*, 1978 (33).
Literature: K. T. Parker in *Old Master Drawings*, XXXVIII, 1935, p. 27, pl. 27.; Hylton Thomas, *The Drawings of Piranesi*, 1954, no. 37, pl. 45; Parker, II, p. 521, no. 1039.

Thomas suggests a date about 1755.

Marco Ricci
1676–1729

19 CLASSICAL RUINS WITH A
 COLUMN RISING IN FRONT
 TO LEFT AND A STATUE
 SEEN THROUGH AN ARCH
 TO RIGHT
 $5^{7}/_{16} \times 7^{3}/_{4}$ in. (14.1 × 19.7 cm.)

20 CLASSICAL RUINS WITH
 AN OBELISK SEEN
 THROUGH AN ARCH TO
 RIGHT AND WITH THE
 STATUE OF A ?LION IN
 THE FOREGROUND TO
 RIGHT, ITS PEDESTAL
 RISING ABOVE FALLEN
 MASONRY
 $5^{11}/_{16} \times 7^{5}/_{8}$ in. (14.5 × 19.4 cm.)
 Two drawings in one mount, each drawn
 with pen and brush in brown ink.
 Collections: Both drawings come from a
 folio volume, the property of Dr. Benno
 Geiger, containing 141 items, which was
 dispersed in lots at Sotheby's, 8 December
 1920 (259–272). The album, consisting
 of eighty-eight leaves, was lettered MAR-
 CO RICCI BELLUNENSIS PICTORIS
 EXIMII SCHEDAE. Twenty-one drawings
 were purchased for the Ashmolean in
 1920 from the Magdalen College Fund.
 Other drawings from the same set passed
 to the British Museum.
 Exhibitions: Venice, Palazzo Sturm, *Marco
 Ricci*, 1964 (163, 167).
 Literature: Parker, II, p. 527, nos. 1065,
 1066; G. M. Pilo, "Marco Ricci ritrovato"
 in *Paragone*, 1963, no. 165, pp. 21–36,
 pls. 36, 37.

21 A CLASSICAL CAPRICCIO
 Gouache; mounted on black-tinted paper.
 A contemporary inscription *Marco Ricci*,
 in large Roman minuscules, is on the *verso*.
 $11^{7}/_{16} \times 16^{1}/_{4}$ in. (29.1 × 41.2 cm.)
 Purchased in 1951.

Exhibitions: Venice, Palazzo Sturm, *Marco
Ricci*, 1964 (89).
Literature: Parker, II, p. 528, no. 1069.

A gouache of almost identical design, 19.5
× 29.5 cm., was lent to the Marco Ricci
exhibition at Venice, no. 90, by Dr. Vittorio
Cucci.

Mauro Antonio Tesi, attributed to
1730–1766

22 ARCHITECTURAL
 FANTASY: A
 MONUMENTAL STAIRWAY
 VIEWED THROUGH
 ARCHES
 $6^{3}/_{4} \times 5^{1}/_{4}$ in. (17.1 × 13 cm.)

23 TWO COLLOCATED
 DESIGNS OF HIGHLY
 ORNATE INTERIORS
 $5^{29}/_{32} \times 7^{7}/_{8}$ in. (15 × 20 cm.)
 Two in one mount, each drawn in pen and
 grey wash (in the case of no. 23, over
 plumbago).
 Collections: Rev. Henry Octavius Coxe
 (1811–1881), Bodley's Librarian, by
 whom said to have been bought at a stall
 in the streets of Florence; his daughter,
 Susan Esther Wordsworth; purchased
 1939.
 Literature: Parker, II, p. 530, nos. 1073,
 1074.

At the time of purchase the drawings were
mounted along with forty-eight others, in
an album of no great age and were attrib-
uted to Guardi. The whole set was removed
from the album, five being placed in mounts
and the remainder in a new album. Draw-
ings by the same hand in the collection of
the Royal Institute of British Architects,
London, are inscribed with the name of
Tesi on the mounts.

Giovanni Battista Tiepolo
1696–1770

24 STANDING FIGURE OF A BEARDED MAN

Pen and brown ink with brown wash over plumbago.
9½×6⅜ in. (23.5×15.8 cm.) (irregular)
Collections: Mr. Victor Rienaecker, by whom presented in 1935.
Exhibitions: Venice, Cini Foundation, *Disegni veneti di Oxford*, 1958 (90).
Literature: Parker, II, p. 537, no. 1083.

In the catalogue of the Venice exhibition Parker associates this drawing with a series of forty-six in the Algarotti–Corniani–Cheney album entitled *Sole figure vestite*, now in the Victoria and Albert Museum. See George Knox, *Catalogue of the Tiepolo Drawings in the Victoria and Albert Museum*, 2nd ed., 1975, pp. 65–70, nos. 131–76. His introduction gives the complete history of the various albums of Tiepolo drawings which belonged to Edward Cheney.

25 HEAD OF A BEARDED MAN IN A FUR CAP

Pen and brown ink and brown wash over black chalk.
9¾×7¹¹⁄₁₆ in. (24.7×19.6 cm.)
Collections: from an album of drawings given by the artist and his son (Giuseppe Maria Tiepolo) to the convent of the Sommaschi, Santa Maria della Salute, Venice, some time before their departure for Spain in 1762; Count Leopold Cicognara; Antonio Canova, the sculptor; his half-brother, Monsignore G. B. Sartori–Canova; Francesco Pesaro; Edward Cheney (1803–1884) by 1842; Col. Alfred Capel Cure; Sotheby's sale, 29 April 1885 (1024 – comprising nine volumes of Tiepolo drawings); perhaps in one of the three volumes bought by E. Parsons and Sons at Christie's, 14 July 1914 (49); the Savile Gallery, London, by 1928 when the album

was dismembered; Richard Owen, Paris; Alan Pilkington by whom bequeathed to the Ashmolean in memory of his wife, Florence Mary, 1973.
Exhibitions: London, Savile Gallery, *Drawings by Giovanni Battista Tiepolo*, May 1928 (29); London, P. & D. Colnaghi, *Old Master Drawings*, April–May 1952 (31); London, Royal Academy, *Drawings by Old Masters*, 1953 (164); London, Victoria and Albert Museum, *International Art Treasures Exhibition*, 1962 (39).

The drawing was one of ninety-three studies of heads in an album which also included about seventy drawn variations on the theme of the Holy Family. The history of the album referred to above is given by George Knox in his catalogue of Tiepolo drawings in the Victoria and Albert Museum (see no. 24).

Francesco Zuccarelli
1702–1788

26 LANDSCAPE WITH WOMEN BATHING

Gouache.
15¹¹⁄₁₆×22³⁄₁₆ in. (39.9×56.3 cm.)
Collections: Viscount Eccles; Alan D. Pilkington, by whom bequeathed in memory of his wife, Florence Mary, 1973.
Exhibitions: London, Royal Academy, *European Masters of the Eighteenth Century*, 1954–55 (594); London, P. & D. Colnaghi, *English Drawings and Watercolours in Memory of D. C. T. Baskett*, 1963 (9); London, Royal Academy, *Bicentenary Exhibition*, 1968–69 (516).

An old label taken from the original frame states that no. 26 is companion to *Market Women and Cattle* in the Victoria and Albert Museum (F.A.610).

English

John White Abbott
1763–1851

27 A LANE LEADING DOWN
TO A COASTAL PLAIN
Pen and ink with blue and grey washes.
11⁷/₈×9¹/₂ in. (30.3×24.1 cm.)
Presented by the Executors of Mr. A. H.
Smith, 1959.

John White Abbott, a surgeon by profession, was a pupil of Francis Towne (see no. 52). He spent the whole of his working life at his birthplace, Exeter, in Devonshire, and never travelled abroad.

William Alexander
1767–1816

28 "THE FOU-YEN
OF CANTON"
Watercolor over pencil.
8¹/₂×6¹⁷/₃₂ in. (20.9×16.6 cm.)
Signed in ink in right lower corner with the initials *W.A.* and inscribed on the back of the contemporary mount, by the artist, *The Fou-yen of Canton – when sitting at Table with the Ambassador,* etc.
Purchased in 1942.

The 1st Earl Macartney, who was ambassador extraordinary and plenipotentiary to Pekin, 1792–94, recorded in his journal that he was received by the Viceroy and the Fu-yuan, or Governor, of Canton on 19 December 1793, and that subsequent visits were exchanged (see *An Embassy to China, Lord Macartney's Journal, 1793–94,* ed. H. Cranmer-Byng, 1962, pp. 203 ff.). William Alexander accompanied him on this mission as a junior draughtsman.

29 PORTRAIT OF
CH'IEN-LUNG,
EMPEROR OF CHINA
Watercolor over pencil.
8³/₄×6¹³/₁₆ in. (22.2×17.3 cm.)
Inscribed by the artist in pencil on *verso, Tchien Lung Emperor of China, 1793.*
Collections: (?)George Cooke, the engraver; Conrad Cooke; L. G. Duke; E. H. North by whom presented, 1973.

Ch'ien-lung, Emperor of China (1736–1796), resigned his throne shortly before his death. Another drawing of him by Alexander, dated 1796, is No. 1 in an album of Alexander's Chinese drawings in the British Museum.

William Blake
1757–1827

30 BEATRICE AND DANTE IN
GEMINI AMID THE
SPHERES OF FLAME
Watercolor and some pen and black ink over pencil and black chalk. Inscribed by the artist, *Paradiso Canto 24.*
13¹⁵/₁₆×20¹/₁₆ in. (35.5×51.1 cm.)
Collections: John Linnell; lot 148 in the Linnell sale, Christie's, 15 March 1918, comprised all Blake's drawings for the *Divina Commedia* and was acquired by a syndicate organized by the National Art-Collections Fund. The drawings were distributed by the N.A.-C.F. to museums and art galleries throughout Britain and the Commonwealth and no. 30 was presented with two others to the Ashmolean Museum.
Exhibitions: Paris, Bibliothèque Nationale, *Aquarelles de Turner, Oeuvres de Blake,* 1937 (28); London, Tate Gallery, *William Blake,* 1978 (337).
Literature: A. Gilchrist, *Life of Blake,* II, 1863 ed., p. 222, no. 103a; *Oxford Magazine,* 21 June 1918, p. 341; National Art-Collections Fund Portfolio, *Illustrations*

to the *Divine Comedy of Dante by William Blake*, 1922, pl. 93; A. S. Roe, *Blake's Illustrations to the Divine Comedy*, 1953, pp. 181–2.

The drawing illustrates *Paradiso*, canto 24, lines 10–18, and shows Dante and Beatrice in the constellation of Gemini, under which Dante was born, surrounded by redeemed spirits.

Giovanni Battista Cipriani
1727–1785

31 A STUDY OF THE
 MONUMENT TO THE
 1ST EARL SPENCER
 (1734–1783)
 IN THE CHURCH OF
 ST. MARY,
 GREAT BRINGTON,
 NORTHAMPTONSHIRE
Pen and ink with grey and buff washes.
14¹/₂×8¹¹/₁₆ in. (36.9×22.1 cm.)
Inscribed in pencil at lower left corner, *Lord Spencer*, and at lower right, *700*.
Collections: Sir Bruce Ingram, from whose collection purchased 1963.
Exhibitions: Oxford, Ashmolean Museum, *English Drawings purchased from the Collection of the late Sir Bruce Ingram*, 1963 (61) as Nollekens.

The tomb of the 1st Earl Spencer at Great Brington was carried out by J. T. Nollekens from the design of Cipriani. There is a somewhat larger drawing similar to no. 31 in the Spencer collection at Althorp but the identification of the draughtsman is in both cases difficult to determine. No. 31 has in the past been attributed to Nollekens himself but it is so close to the hand of Cipriani that the attribution to him rather than to Nollekens is almost a certainty. Whether it is a preliminary drawing for the monument or a drawing taken from the

monument *in situ* is again in question. The monument originally stood against an unplastered wall in the Spencer Chapel, but was later moved to another location in the Chapel.

John Robert Cozens
1752–1797

32 ENTRANCE TO THE
 VALLEY OF THE GRANDE
 CHARTREUSE IN DAUPHINÉ
Watercolor. Inscribed in ink on *verso*, *Approach to the Grand Chartreuse in Dauphiny*.
10¹/₄×14⁷/₈ in. (26.1×37.7 cm.)
Collections: William Beckford, Christie's sale, 10 April 1805 (30); Sir Richard Colt Hoare; F. Pierrepont Barnard, by whom bequeathed, 1934.
Exhibitions: London, Burlington Fine Arts Club, *Drawings by John Robert Cozens*, 1922–23 (53).
Literature: C. F. Bell and Thomas Girtin, "The Drawings and Sketches of John Robert Cozens," *Walpole Society*, XXII, 1935, p. 79.

No. 32 is based on an undated study which is the last item in the sketchbooks kept by Cozens on his travels in Europe with William Beckford, 1782–83 (Vol. VII, [no. 107], now in the Whitworth Art Gallery, University of Manchester). A tracing of this study dated 25 October 1783, is in a volume of studies by Cozens which belonged to Sir George Beaumont.

33 SEPULCHRAL REMAINS IN
 THE CAMPAGNA
Watercolor and some body color over indications in pencil.
10¹/₄×14¹¹/₁₆ in. (26×37.3 cm.)
Collections: William Beckford, Christie's sale, 10 April 1805 (81) bt. Edridge (probably Henry Edridge, the portrait draughts-

man); F. Pierrepont Barnard by whom bequeathed, 1934.

Exhibitions: London, Burlington Fine Arts Club, *Drawings by John Robert Cozens*, 1922–23 (56); Rome, *Il Settecento a Roma*, 1959 (181); Washington, National Gallery, and New York, Metropolitan Museum, *English Drawings and Watercolours from British Collections*, 1962 (26); Manchester, Whitworth Art Gallery, and London, Victoria and Albert Museum, *Watercolours by John Robert Cozens*, 1971 (80); London, Royal Academy, *The Age of Neo-Classicism*, 1972 (549); London, Kenwood, Iveagh Bequest, *British Artists in Rome*, 1700–1800, 1974 (116).

Literature: T. Ashby, "Topographical Notes on Cozens," in *The Burlington Magazine*, XLV, 1924, p. 194; Bell and Girtin, *op. cit.* (no. 32), p. 73, no. 370; A. P. Oppé, *Alexander and John Robert Cozens*, 1952, p. 148; H. Lemaitre, *Le Paysage Anglais à l'Aquarelle*, 1955, p. 128.

Dated by Bell and Girtin to *c.* 1783. This drawing has long been recognized as one of the masterpieces of Cozens. Ashby (see above) identifies the scene as taken from a point on the Via Appia and suggests that the ruins in the foreground are those of the Villa of the Quintilii.

John Flaxman
1755–1825

34 DESIGN FOR A TOMB MONUMENT
Pen and black ink and bistre washes over indications in pencil. Inscribed in pencil at right upper corner, 73.
$12^{17}/_{32} \times 8^3/_4$ in. (30.13×22.3 cm.)
Purchased in 1963.
Exhibitions: Bregenz, Vorarlberger Landesmuseum, and Vienna, Österreichisches

Museum für Angewandte Kunst, *Angelica Kauffmann und ihre Zeitgenossen*, 1968–69 (212a).

Flaxman, an exponent of the neo-classical style in sculpture, was a man of a powerful imagination, as is evident in this design for a monument (believed not to have been executed). He was a friend of both Blake and Romney, and like Romney, gave evidence in some of his drawings of a creative force never fully exploited.

Henry Fuseli
1731–1825

35 (?) CHRIMHILD MEDITATING REVENGE OVER THE SWORD OF SIEGFRIED
Pen and brush in brown ink.
$13^5/_8 \times 13^{17}/_{32}$ in. (34.6×34.4 cm.)
Inscribed in brown ink near lower center, *London 9º Jul.*, and along the upper right margin a quotation in Greek from Homer, *Odyssey*, XVI, I, 294, which may be translated "the iron draws a man on."
Collections: Baroness North; Mr. R. E. A. Wilson, by whom presented, 1935.
Exhibitions: London, R. E. A. Wilson, *Paintings and Drawings by Henry Fuseli*, 1935 (19) as "Chrimhild departing."
Literature: Nicolas Powell, *The Drawings of Henry Fuseli*, 1951, p. 40, no. 28 as "Classical Scene"; E. de Keyser, *The Romantic West 1789–1850*, 1965, p. 180; Gert Schiff, *Johann Heinrich Füssli*, 1974, pp. 544–5, no. 1042.

The subject of this drawing remains in doubt. Powell suggests a connection with the passage in the *Odyssey* where Odysseus begins to think of revenge, but both he and Schiff also draw attention to Fuseli's lost painting, exhibited 1799, no. 34, for the Milton Gallery, *Chrimhild meditating revenge over the sword of Siegfried*, a sub-

ject which was somewhat obscurely related in the exhibition catalogue to the lines from *Il Penseroso*: "Or call him up that left half told / The story of Cambuscan Gold— / And if *aught else* great bards beside / In sage and solemn tunes have sung—"

36 CASSANDRA RAVING
Red and grey washes, heightened with white in the face, over indications in pencil and black chalk, on fine tissue.
13⅝×9 in. (34.6×22.7 cm.) Watermark 1802.
Collections: Dr. Grete Ring, by whom bequeathed, 1954.
Literature: R. Todd, *Tracks in the Snow*, 1946, *repr.* pl. 23; Schiff, *op. cit.* (no. 35), p. 607, no. 1525.

Schiff dates this drawing 1810–15.

Thomas Gainsborough
1728–1788

37 STUDY OF A WOMAN, SEEN FROM THE BACK
Black chalk and stump, heightened with white on greyish-brown paper.
19³/₁₆×11¹⁵/₁₆ in. (48.8×30.4 cm.)
Collections: Among the drawings inherited from Gainsborough by his widow; by family descent to Henry Briggs, or via Sophia Lane to Richard Lane; probably Lane sale, Christie's, 25 February 1831 (part of lot 97 or 99); Sir George Donaldson (Puttick and Simpson's sale, Hove, 7 July 1925 [216]); E. Buchanan (Puttick and Simpson's sale, 23 July 1936 [49]); Anon. (= F. Lesser), Christie's sale, 11 June 1937 (49); E. A. Mott; Mrs. Alice Jessie Mott by whom bequeathed, 1959, in memory of her husband, Charles Egerton Mott, Commoner of Oriel College.
Exhibitions: British Council (Hamburg, Oslo, Stockholm and Copenhagen), *British Painting from Hogarth to Turner*, 1949–50 (52); Munich, Residenz, *Euro-*

päisches Rokoko, 1958 (277); Sudbury, Gainsborough's House, *The Painter's Eye*, 1977 (11).
Literature: Ashmolean Museum, *Report*, 1959, pp. 41–2, *repr.* pl. XI; John Hayes, *The Drawings of Thomas Gainsborough*, 1970, p. 118, no. 30.

The woman's costume indicates a date in the 1760's. The Ashmolean *Report* suggests that the drawing may have been made from an articulated doll, but, as Hayes points out, the general effect seems too natural and animated for this to be likely. There is a tradition that this model was Mrs. Gainsborough drawn on her way to church, but there is no evidence to support it.

38 LANDSCAPE WITH A RUINED CASTLE AND CATTLE BY A POOL
Black chalk and watercolors, heightened with white, on pale buff paper.
8²¹/₃₂×12²/₁₆ in. (22×31.2 cm.)
Collections: Henry J. Pfungst; Christie's sale, 15 June 1917, (23); P. & D. Colnaghi; Knoedler; F. F. Madan; purchased 1951.
Exhibitions: London, P. & D. Colnaghi, *Studies and Drawings by Thomas Gainsborough*, 1906 (35); New York, Knoedler, *Pictures by Gainsborough*, 1923 (2); London, 45, Park Lane, *Gainsborough Loan Exhibition*, 1936 (70); Paris, Louvre, *La Peinture Anglaise*, 1938 (200); Geneva, Musée Rath and L'Ecole Polytechnique Fédérale, *L'Aquarelle Anglaise 1750–1850*, 1956 (63); Sudbury, Gainsborough's House, *The Painter's Eye*, 1977 (17).
Literature: Mary Woodall, *Gainsborough's Landscape Drawings*, 1939, p. 121, no. 221; John Hayes, *The Drawings of Thomas Gainsborough*, 1970, text p. 283, no. 761.

Gainsborough's landscape drawings are more often imaginary than topographical and no. 38 has not as yet been associated with a particular location.

Thomas Girtin
1775–1802

39 WEST FRONT OF PETERBOROUGH CATHEDRAL

Watercolors over indications in pencil, signed and dated in black ink at lower center, *T. Girtin 1794*.

15×11⁵/₁₆ in. (38.1×28.3 cm.)

Collections: James Moore, F.S.A.; by descent to E. M. Miller, Fellow of Magdalen College, Oxford (d. 1912), and his sister, Helen Louisa; purchased from a Fund provided by Magdalen College, 1916.

Exhibitions: London, Royal Academy, 1795 (611); Manchester, *Art Treasures Exhibition*, 1857 (73); London, Arts Council, *English Romantic Art*, 1947 (24); London, Royal Academy, *The First Hundred Years of the Royal Academy, 1769–1868*, 1951–52 (490); Paris, Petit Palais, *La Peinture Romantique Anglaise et les Preraphaélites*, 1972 (129); Manchester, Whitworth Art Gallery, and London, Victoria and Albert Museum, *Watercolours by Thomas Girtin*, 1975 (10).

Literature: C. F. Bell, "Fresh Light on Some Watercolour Painters of the Old British School," in *Walpole Society*, v, 1915–17, pp. 71 and 74; Randall Davies, *Thomas Girtin's Watercolours*, 1924, pp. 1 and 14, *repr.* pl. 14; Martin Hardie, "Thomas Girtin: the Technical Aspect of his Work," *Old Water-Colour Society's Club*, xi, 1934, p. 4; Jonathan Mayne, *Thomas Girtin*, 1949, pp. 31, 43, 49 and 91; Thomas Girtin and David Loshak, *The Art of Thomas Girtin*, 1954, pp. 28, 55, 62, 78 and 145; Francis Hawcroft, *Catalogue of Exhibition of Watercolours by Thomas Girtin*, 1975, p. 30; Christopher White, *English Landscapes 1630–1850*, Yale, 1977, p. 65, under no. 112.

One of at least four watercolors based on the pencil drawing, made during Girtin's tour of the Midlands with James Moore in 1794, which is now in the Mellon Collection at the Yale Center. The Ashmolean drawing records the original appearance of the Yale sheet before its top portion, showing the upper arcades of the tower, was cut and replaced by a strip showing a loftier treatment of the feature. The detached portion was last recorded in the collection of the late Sir Edward Marsh. Thus the Ashmolean drawing shows one less arcade than now appears at Yale and is faithful to the building as it stands, as is another watercolor of the cathedral, signed and dated 1794, formerly with W. Tryon but now untraced. Other versions are in the Spooner Bequest to the Courtauld Institute of Art, London, and the Whitworth Art Gallery, Manchester. Yet another was recorded in the collection of R. P. H. Goodall in 1960 (Sotheby's sale, 22 April 1959 [26] under an attribution to Turner).

40 CROWLAND ABBEY, LINCOLNSHIRE

Watercolors over indications in pencil.

13×11³/₄ in. (33.1×29.9 cm.)

Twice signed in black ink, at left lower corner and on the old washed border (now removed), *Girtin*.

Collections: Miller family; F. Pierrepont Barnard (great-grandson of Girtin), by whom bequeathed, 1934.

Exhibitions: London, Burlington Fine Arts Club, *The Works of Thomas Girtin*, 1875 (47); Manchester, Whitworth Art Gallery, and London, Victoria and Albert

Museum, *Watercolours by Thomas Girtin*, 1975 (3).
Literature: Mayne, *op. cit.*, p. 99; Girtin and Loshak, *op. cit.*, p. 141, no. 52; Hawcroft, *op. cit.*, p. 27.

Based on two pencil drawings by James Moore (1762–1799) dated 12 September 1789, one of which seems to have been completed by another hand, possibly Girtin's (Moore Album, nos. 7 and 8). Moore was a business man and an amateur artist, deeply interested in antiquarian and topographical matters, who employed others, notably Girtin, to make drawings for him which were often based on his own sketches. The present watercolor was engraved by B. Howlett for his *Selection of Views in the County of Lincoln*, 1805, no. 8, and is dated by Girtin and Loshak to 1793. The engraving is lettered *Drawn by T. Girtin from a sketch by James Moore Esqr.* and dated 22 August 1797. An earlier state of the plate dated 11 July 1797, differs in several respects both from the drawing and the published engraving.

Charles Grignion I

1721–1810

41 A GENTLEMAN WEARING A GOWN
Black chalk and stump, heightened with white, on blue paper.
Inscribed in pencil on *verso* in an old hand, *Grignon*.
14 1/2 × 8 9/16 in. (36.9 × 21.1 cm.)
Presented by Miss Drummond, 1950.

The drawing closely resembles another by Hubert Gravelot also in the Ashmolean Museum (see no. 74). In Gravelot's draw-

ing the head is seen in full profile and the coat is tied by a sash. Grignion perhaps based this drawing on that of Gravelot, and in fact he surpasses it in quality. He became Gravelot's pupil at the age of ten.

Hugh Douglas Hamilton

c. 1734–1806

42 MRS. ELIZABETH HARTLEY IN THE CHARACTER OF JANE SHORE
Pastel chalks.
Oval: 8 × 6 3/4 in. (20 × 16 cm.)
Inscribed in an old hand on the former backboard, *Mrs. Hartley the Actress FACG as Jane Shore Oct. 5 1772 died Feb. 2 1824 aged 73 Hamilton pinxt. In Mr. Meyer's Collection.*
Collections: (?) Jeremiah Meyer, miniature-painter; E. J. Duveen; F. M. Evans; purchased, 1938.
Exhibitions: Paris, *Exposition de Pastellistes Anglais du XVIII Siècle*, 1911 (64).

The head corresponds exactly, on a reduced scale, to that in the mezzotint by R. Houston published by R. Sayer and J. Bennett in 1774 (J. Chaloner Smith, *British Mezzotint Portraits, 1878–1882*, II, pp. 667–8, no. 62) but it is likely that the engraving was based on another version recorded by W. G. Strickland (*Dictionary of Irish Artists*, I, p. 440) as in the collection of the Duke of Leinster, 1913. Elizabeth Hartley (née White) (1751–1824), tragic actress, made her début at Covent Garden in the title role of Rowe's *Jane Shore*, 5 October 1772.

Thomas Jones

1742–1803

43 ROOFTOPS IN NAPLES

Oil on paper.
5 1/8 × 13 13/16 in. (14.2×35 cm.)
Signed in monogram *T.J.* in pencil on *verso*, and inscribed and dated *Naples Aprile 1782*.
Collections: The artist's family; Christie's sale, 2 June 1954 (from lot 213); purchased 1954.
Exhibitions: Detroit, Institute of Arts and Philadelphia, Museum of Art, *Romantic Art in Britain 1760–1860*, (72); Norwich, Castle Museum, and London, Victoria and Albert Museum, *A Decade of English Naturalism*, 1969 (27); Twickenham, Marble Hill House, *Thomas Jones*, 1970 (60).
Literature: John Woodward, *A Picture History of British Painting*, 1962, p. 85; Luke Herrmann, *British Landscape Painting of the 18th Century*, 1973, p. 68.

A view from the roof of the Neapolitan lodgings where Jones lived from May, 1780 until the expiry of the lease on 3 May 1782. The same building, the Dogana del Sale, or Custom House for Salt, appears in an oil sketch in the National Museum of Wales (no. 61, *repr.* in the 1970 exhibition catalogue). See "Memoirs of Thomas Jones," published in *Walpole Society*, XXXII, 1956–58, p. 95.

Marcellus Laroon

1679–1772

44 "CUDGELING"

Pen and brown ink with grey and some brown wash over pencil.
Inscribed by the artist with the title at center of lower margin and at right with his age, signature and the date *Aetatis 92. Marcellus Laroon F. 1770*.
18 11/16 × 27 in. (47.5×68.5 cm.)

Collections: Francis Douce, by whom bequeathed to the Bodleian Library, 1834; transferred to the University Galleries, 1863.
Exhibitions: Aldeburgh (Festival) and London, Tate Gallery, *Marcellus Laroon*, 1967 (48).
Literature: Robert Raines, *Marcellus Laroon*, 1966, pp. 86 and 135, no. 65.

The sport of cudgelling, that is of combat with stout wooden clubs known as cudgels, was widely practiced in Laroon's time, especially in the west of England. It is discussed by J. Eyles in an article, "Backsword or Singlestick?," *Country Life*, 8 July 1965, p. 108. No. 44 is one of several large-scale complicated figure compositions produced by Laroon in his nineties.

John Baptist Malchair

1731–1812

45 A VIEW FROM
 MR. NARE'S ROOMS AT
 MERTON COLLEGE,
 OXFORD

Pencil and watercolor. Dated in brown ink *1791*, at lower right. Inscribed on the back in the artist's hand *Feb. 28-1791-/5 From The Roomes of Mr Nares at Merton Coll. Oxon.*
7 15/16 × 12 13/16 in. (20.2×32.9 cm.)

Edward Nares (1762–1841) was a Fellow of Merton, 1788–90. Shortly afterwards he became librarian to the Duke of Marlborough at Blenheim Palace. It seems that he still kept rooms at Merton in February, 1791. He was Bampton lecturer in the University of Oxford in 1805 and Regius Professor of Modern History, 1813–41.

J. B. Malchair, a native of Cologne, came to London in 1754. In 1759 he settled in Oxford, where he was appointed leader of the Oxford Music Room orches-

tra. He was also a popular drawing-master. Many of his sensitive drawings of Oxford and the district are in the Ashmolean Museum.

Allan Ramsay
1713–1784

46 A NUDE WOMAN SEEN FROM BEHIND
> Black and white chalks, touched lightly with red in the hair on faded blue paper.
> 16 1/2 × 10 25/32 in. (41 × 27.5 cm.)
> Collections: J. P. Heseltine; P. M. Turner, by whom presented, 1942.

A life study, perhaps made during Ramsay's second stay in Italy, 1754–57, when he often drew from the nude model at the French Academy in Rome.

Sir Joshua Reynolds, P.R.A., ascribed to
1723–1792

47 PORTRAIT OF FELICE DE'GIARDINI
> Pen and brown ink on coarse buff paper.
> 8 3/4 × 6 5/8 in. (21.4 × 16 cm.)
> Inscribed in brown ink across the sitter's breast, apparently by the artist, *The Famous Giardini.*
> Purchased in 1941 (Hope Collection).

A spirited drawing by a good hand, formerly ascribed to John Jackson, R.A., but placed within the Reynolds circle in the Museum's *Report*, 1941, p. 27. The sitter was a friend of G. B. Cipriani and of Gainsborough, whose portrait of him belongs to Lord Sackville. The drawing is not indubitably by Reynolds although the head compares with the mezzotint by S. W. Reynolds said to be after a sketch by Sir Joshua (British Museum: *Catalogue of*

Engraved British Portraits, II, 1910, p. 325). Reynolds is known to have given a single appointment for a sitting to "Mr. Giardini" on 4 November 1755 (E. K. Waterhouse, "Reynolds's 'Sitter Book' for 1755," *Walpole Society*, XLV, 1966–68, pp. 136 and 150).

Felice de'Giardini (1716–1796), composer and virtuoso violinist, a native of Turin, came to London in 1749/50. He became chamber musician to the Dukes of Gloucester and Cumberland. Late in life he returned to Italy and *c.* 1792 travelled to seek work in Russia. He died in poverty in Moscow.

George Romney
1734–1802

48 (?) A SCENE FROM DANTE'S "INFERNO"
> Bistre wash over faint indications in black chalk, on coarse buff paper.
> 12 5/8 × 17 15/16 in. (32 × 45.7 cm.)
> Purchased in 1945.

The title is that under which the drawing was acquired but it can only be conjectural. Romney's powerful, imaginative drawings which are often related to literary subjects—particularly subjects from Shakespeare and Milton—indicate a promise of achievement which was never fulfilled. There are many in the Fitzwilliam Museum, Cambridge.

Thomas Rowlandson
? 1756–1827

49 THE APPLE VENDOR: "BAKING AND BOILING APPLES"
> Pen and reddish brown ink and watercolors over indications in pencil.

$10^{15}/16 \times 8^{1}/2$ in. (27.8×21.7 cm.)
Inscribed in brown ink at right lower corner, *Baking and Boiling Apples*. The inscription protrudes slightly on to the washed and lined mount which seems to confirm that mounts of this type were prepared by or for the artist himself.
Collections: Francis Douce, by whom bequeathed to the Bodleian Library, 1834; transferred to the University Galleries, 1863.
Literature: R. Paulson, *Rowlandson*, 1972, pp. 35 and 125, no. 15.

The drawing is reminiscent of Rowlandson's *Cries of London* series, issued in 1799, of which only plates 1–6 and 8 are at present known. For these see J. Grego, *Rowlandson the Caricaturist*, 2 vols., 1880, I, pp. 354–7. Two somewhat similar drawings of street sellers, with later inscriptions claiming that they are unused designs for the *Cries*, are in the Huntington Library (R. Wark, *Rowlandson Drawings*, 1975, p. 58, nos. 101–2, *repr*.).

50 AN OLD VERGER
SHOWING THE TOMBS IN
WESTMINSTER ABBEY
Pen and reddish brown ink and watercolors over indications in pencil.
$12^{5}/8 \times 9^{1}/2$ in. (32.1×24.2 cm.)
Signed and dated at right lower corner *Rowlandson 1810*.
Collections: Sir John Crampton (Christie's sale, 16 April 1923, lot 17, bt. in); Miss S. A. P. Boyle, by whom bequeathed, 1967.
Literature: R. Paulson, *Rowlandson*, 1972, p. 95.

John Raphael Smith
1752–1812

51 A LADY AND CHILD
Black and red chalks.

$11^{3}/8 \times 8^{7}/8$ in. (28.9×22.6 cm.)
Collections: T. H. Cobb; K. T. Parker, by whom presented, 1946.
Literature: *Vasari Society*, 2nd series, Part XV, *repr*. in color, pl. 9.

Francis Towne
1739/40–1816

52 "A VIEW FROM THE
CASCADE IN THE GROVES
AT AMBLESIDE"
Pen and brown ink and watercolors.
$14^{13}/16 \times 10^{7}/16$ in. (37.6×26.5 cm.)
Signed in brown ink at right lower corner *F. Towne/delt.1786.*, and inscribed in the artist's hand on the back of the old mount with the title, as above, and *The Head of the Lake of Windermere drawn on the Spot by Francis Towne August 10th. 1786/NB. The paper this is drawn on I brought myself from Rome.*
Collections: Merivale family (inherited from the artist); Miss Merivale and Miss J. Merivale, by whom presented, 1922.
Exhibitions: Louisville, Kentucky, J. B. Speed Art Museum, *British Watercolours 1750–1850*, no. 21, *repr*. (and as frontispiece in catalogue by Stephen Somerville).
Literature: A. P. Oppé, "Francis Towne, Landscape Painter," *Walpole Society*, VIII, 1919–20, pp. 121–2, *repr*. pl. LXVI; Martin Hardie, *Water-colour Painting in Britain*, I, 1966, p. 123, *repr*. pl. 98; Luke Herrmann, *British Landscape Painting of the 18th Century*, 1973, p. 78, *repr*. pl. 77.

A work made during the artist's journey to the Lake District in 1786 with his Exeter friends, James White and John Merivale. Oppé (*op. cit.*) refers to it as one of three drawings made from almost precisely the same point of view; a variant in his own collection now belongs to Mr. D. L. T. Oppé.

Joseph Mallord William Turner
1775–1851

53 TRANSEPT OF TINTERN ABBEY, MONMOUTHSHIRE
Watercolors over pencil with pen and ink.
13 7/8 × 10 1/4 in. (35.3 × 26.1 cm.)
Inscribed (perhaps a signature) with pen near right lower corner, *Turner*.
Collections: James Moore, F.S.A.; by descent to E. M. Miller, Fellow of Magdalen College, Oxford (d. 1912), and his sister, Helen Louisa; purchased from a Fund provided by Magdalen College, 1916.
Exhibitions: Probably R.A. 1795 (589); Manchester, *Art Treasures of the United Kingdom*, 1857 (297).
Literature: C. F. Bell, *Some Water-Colour Painters of the Old British School, Walpole Society*, v, 1917, p. 77, *repr.* pl. xxvii; A. J. Finberg, *The Life of J. M. W. Turner*, 2nd ed., 1961, pp. 24, 25, 458; Luke Herrmann, *Ruskin and Turner*, 1968, p. 103, *repr.* pl. v.

Turner visited Tintern in 1792 and possibly again in 1793. A version of no. 53, formerly in the collection of R. W. Lloyd and now in the British Museum, is generally regarded as a repetition.

Wordsworth's famous poem, *Lines composed a few miles above Tintern Abbey*, was written in July, 1798, a few years later than the execution of this drawing.

Richard Westall, R.A.
1765–1836

54 LADY MACBETH WALKING IN HER SLEEP
Pen and point of the brush in brown ink and watercolors.
10 × 7 7/16 in. (25.6 × 18.9 cm.)

Signed and dated in brown ink at right lower corner, *R.W.1799*.
Collections: The Rev. Robert Finch, by whom bequeathed to the Taylor Institution, Oxford; transferred to the Ashmolean Museum, 1971.

Engraved on a reduced scale and with several variations by W. C. Wilson for Boydell's *Shakespeare Gallery*, and published 29 September 1799. The subject is from *Macbeth*, Act v, sc. 1, at the point where Lady Macbeth, walking in her sleep, discloses the secret of the King's murder to her doctor and attendant lady. An identical drawing signed and dated 1797, of which this is presumably a replica, is in the Victoria and Albert Museum, London (Dyce Bequest, 912).

Richard Wilson, R.A.
1714–1782

55 "SIGNORA FELICE BOCCA STRETTO"
Black chalk and stump on white paper.
6 3/8 × 9 in. (16.3 × 22.8 cm.)
Inscribed in black chalk at right upper corner, *Sigra. Felice Bocca Stretto*, no doubt a nickname.
Collections: Chambers Hall, by whom presented to the University Galleries, 1855.

Described in the inventory of the Chambers Hall Gift (no. 4) as *Girl with wide mouth*. Almost certainly, like no. 56, drawn from the life during Wilson's stay in Italy, 1750–56.

56 A BOY WEARING A CAP
Black chalk on white paper.
5 7/8 × 5 3/4 in. (14.4 × 14.2 cm.)
Collections: Chambers Hall, by whom presented to the University Galleries, 1855.

The drawing is on an old mount, with grey wash border, which has been considerably cut down. Indications of a drawing on the *verso* can be seen through the paper.

57 THE RUINED ARCH AT KEW
Red, black and white chalks on blue paper. 9¹¹/₁₆×13³/₁₆ in. (24.6×33.5 cm.) (irregular).
On *verso*, a slight black chalk sketch of an urn.
Collections: The Rev. Robert Finch, by whom bequeathed to the Taylor Institution, 1830; transferred to the Ashmolean, 1971.
Exhibitions: London, Tate Gallery, *Landscape in Britain c. 1750–1850*, 1973, no. 34, *repr.* in catalogue by Leslie Parris.

One of two known studies for Wilson's painting in the collection of Mr. Brinsley Ford (W. G. Constable, *Richard Wilson*, pp. 178–9, *repr.* pl. 41a). The other (Brinsley Ford, *The Drawings of Richard Wilson*, *repr.* p. 71) is in the Glynn Vivian Art Gallery, Swansea, and was exhibited with no. 57 at the Tate Gallery (see above), as no. 33. Another drawing of the same subject, possibly also a study for the painting, was in the William Esdaile sale, Christie's, 21 March 1838, lot 781, "The Roman Ruins in Kew Gardens; heightened with brilliant effect." The painting was formerly known as "Villa Borghese," and the correct identification was first published by Douglas Cooper, "Richard Wilson's Views of Kew," in *The Burlington Magazine*, XC, 1948, pp. 346–8. The arch was built 1759–60, from the design of Sir William Chambers, in imitation of a Roman ruin, and survives today.

Johan Zoffany, R.A.
1733–1810

58 A MUSICAL PARTY
Pen and brown ink roughly touched with bistre wash.
5¹/₄×6¹/₂ in. (13.4×16.5 cm.) (irregular).
Very faintly inscribed in pencil at lower center, *Drawn by Zoffany* and in brown ink on *verso* by Francis Douce, *Certainly by Zoffani*.
Collections: Francis Douce, by whom bequeathed to the Bodleian Library, 1834; transferred to the University Galleries, 1863.
Exhibitions: London, National Portrait Gallery, *Johan Zoffany*, 1976 (121). The drawing, on an old mount with a washed border, was apparently cut from a sketchbook, and is perhaps the sheet whose acquisition is recorded in Douce's *Diary of Antiquarian Purchases* (Bodleian MSS. Douce e 66–68) for August, 1816. Mary Webster in her catalogue of the National Portrait Gallery exhibition (see above) dates it provisionally *c.* 1765, and notes the lack of comparable drawings by Zoffany. It has no close connection with any known group portrait by him.

French

Lambert Sigisbert Adam
1700–1759

59 SELF-PORTRAIT
Red chalk.
14³/₄ × 9³/₄ in. (37.5 × 24.7 cm.)
Inscribed on the tablet below the window sill, *Lambert Sigisbert Adam . . . de Nancy/ Sculpr Ordre du Roy tres cretien . . . de L'Academi . . . Royalle de Sculpr. de Peinture/dessigne par luy meme.*
Collections: Francis Douce, by whom bequeathed to the Bodleian Library, 1834; transferred to the University Galleries, 1863.
Exhibitions: London, Royal Academy, *France in the Eighteenth Century,* 1968 (1).

The sculptor sits within the stone framework of a window through which can be seen two of his own works, a marble figure of Neptune (his *morceau de réception* for the Académie Royale de Sculpture et de Peinture, 1737), based on the Bernini figure now in the Victoria and Albert Museum, London, and a group of River Gods (*Seine* and *Marne*) commissioned by the Duc d'Orléans for the park at St. Cloud in 1733. In his left hand he holds several sheets of drawings. That on the top corresponds with his group *La Chasse,* and that beneath it (just visible) with *La Pêche,* for both of which he made models in 1739, although the corresponding marbles (now at Potsdam) were not completed until a decade later. This suggests that no. 59 was itself drawn around 1739/40.

A portrait of Adam painted by Perronneau in 1753 and now in the Louvre, was this artist's *morceau de réception* at the Académie. It is reproduced by Vaillat and Ratouis de Limay in *J.-B. Perronneau,* Paris, s.a., pl. 47, p. 94, no. 52.

Jean Barbault
1718–1762

60 THE PAINTER CLÉMENT IN TURKISH COSTUME: "PRESTRE DE LA LOY"
Red chalk.
18¹³/₁₆ × 14 in. (47.3 × 35 cm.)
Inscribed in ink at the bottom of the drawing in another hand, *J. Vien.*
There is an offset from a red chalk sketch of a seated male figure in full draperies on the *verso.*
Collections: Vente Mme. V., Paris, 25 March 1925, lot 117, attributed to Vien; Christie's, 30 March 1976, lot 102; purchased with the aid of contributions from the National Art-Collections Fund and from The Trustees of the Festival of Islam, 1976, in memory of Mr. Denys Munby (1919–1976), Fellow of Nuffield College.
Literature: F. Boucher, "An Episode in the Life of the Académie de France à Rome" in *The Connoisseur,* CXLVIII, October, 1961, p. 88; N. Volle and P. Rosenberg, *Jean Barbault,* exhibition catalogue (Beauvais, Angers and Valence, 1974–75), p. 34, no. 33, *repr.* pl. XIV.

No. 60 belongs to a series of drawings and paintings by various hands (mostly Barbault and Vien) which depict participants in a *mascarade à la turque* organized by students of the French Academy in Rome as part of the Carnaval Romain in 1748. They were commissioned by the Director of the Academy, Jean François de Troy. Thirty of the drawings were etched by Vien and published as *Caravane du Sultan à la Mecque, Masquerade turque donnée à Rome par Messieurs les Pensionnaires de l'Académie de France et leurs amis au Carnaval de l'année 1748.*

The painter Clément may be either Brice Clément or Jean-Pierre Clément, both of whom were admitted to the Academy of St. Luke in 1748, but are otherwise unrecorded.

Louis-Philippe Boitard

active between 1738 and 1760

61 A TEA PARTY
Pen and ink over preliminary work in
black lead.
8⁵/₈×12³/₈ in. (21.9×31.5 cm.)
Collections: Francis Douce, by whom be-
queathed to the Bodleian Library, 1834;
transferred to the University Galleries,
1863.
Literature: Parker, I, p. 234, no. 474.

Boitard is said by Binyon (see below) to
have been brought to England (date un-
specified) by his father and it is clear from
no. 61 that he was influenced by the narra-
tive style of Hogarth and Highmore. The
setting of no. 61 appears to be an English
interior. Other drawings by Boitard in the
same style are in the British Museum and
are recorded by Laurence Binyon in his
*Catalogue of Drawings by British Artists
and Artists of Foreign Origin working in
Great Britain . . . in the British Museum*, I
(1898), p. 131.

François Boucher

1713–1770

62 A YOUNG GIRL
 CARRYING A DOG
Black chalk.
6⁷/₈×4⁷/₈ in. (17.4×12.5 cm.)
Collections: Blondel d'Azaincourt; Ran-
dall Davies; F. F. Madan, by whom be-
queathed, 1961.
Exhibitions: London, Royal Academy,
Drawings by Old Masters, 1953 (395);
London, P. & D. Colnaghi, *Memorial Ex-
hibition . . . the Collection of Francis Fal-
coner Madan*, 1962 (52); London, Royal
Academy, *France in the Eighteenth Cen-
tury*, 1968 (82).

Engraved in reverse in sanguine by Gilles
Demarteau when in the collection of Ma-

dame d'Azaincourt. Similar studies of
young girls seen from behind are repro-
duced by A. Ananoff, *L'Oeuvre dessiné de
Boucher*, 1966, figs. 13, 14.

63 MARS AND VENUS
Brown chalk over a preliminary sketch of
the principal figure in charcoal.
7⁵/₈×9³/₁₆ in. (19.4×23.4 cm.)
Collections: Mrs. Bromley Taylor; pur-
chased in 1924.
Literature: Parker, I, p. 234, no. 476.

A similar composition, drawn with the pen
on pink paper and heightened with white,
was formerly in the J. P. Heseltine collec-
tion (see L. Guiraud, *Dessins de l'Ecole
française du XVIIIᵉ siècle provenant de la
Collection H.*, 1913, no. 3, and A. Anan-
off, *L'Oeuvre dessiné de Boucher*, 1966, p.
209, no. 808, *repr.* fig. 128).

Louis de Carmontelle

1717–1806

64 "LE JEUNE COMTE DU
 LAU EN FACTION DEVANT
 LE LOGIS DE SON PÈRE"
Black and red chalk and wash; mounted
on card with black painted border and a
green wash.
13⁵/₁₆×8⁵/₁₆ in. (34×21.1 cm.)
Inscribed as above on the mount.
Purchased in 1938.

No. 64 is a replica of the drawing by Car-
montelle in the Musée Condé, Chantilly
(see F.-A. Gruyer, *Chantilly: Les Portraits
de Carmontelle*, 1902, p. 108, no. 147).
The du Lau family had numerous branches
and the sitter has not been identified pre-
cisely. He seems to be no more than eight
or ten years old and wears the uniform of
the régiment de Neustrie which was au-
thorized 31 May 1776. Gruyer dates the
portrait 1777–80.

Charles-Nicolas Cochin the Younger
1715–1790

65 "LA SOIRÉE"
Red chalk over a faint outline sketch in charcoal.
$9^5/8 \times 13^1/8$ in. (24.4×33.3 cm.)
Signed *Cochin* in right lower corner.
Collections: Paignon-Dijonval; Francis Douce, by whom bequeathed to the Bodleian Library, 1834; transferred to the University Galleries, 1863.
Exhibitions: London, Royal Academy, *French Art*, 1932 (842); and *France in the Eighteenth Century*, 1968 (159).
Literature: S. Colvin, *Drawings in the University Galleries*, vol. III, 1907, 42; Parker, I, p. 237, no. 482.

The drawing was engraved in reverse by Claude Gallimard in 1739 under the title *La Soirée* (see C.-A. Jombert, *Catalogue de C.-N. Cochin fils*, 1770, p. 22, no. 59, and S. Rocheblave, *C.-N. Cochin*, 1927, pl. XVII).

66 "VUE DE L'ENTRÉE DU JARDIN DE LA TIRELIRE"
Body color and wash over black chalk within a ruled and washed margin.
$9^3/16 \times 6^1/4$ in. (23.6×16 cm.)
Signed and dated *Cochin filius 1746*.
Collections: presented by Mr. F. A. Drey through the National Art-Collections Fund, 1938.
Exhibitions: London, Royal Academy, *Landscape in French Art*, 1949–50 (523); and *France in the Eighteenth Century*, 1968 (160).

In a letter dated 18 February 1938, the Conservateur of the Musée Carnavalet, Paris, states that the existence and whereabouts of a "Jardin de la Tirelire," presumably in Paris, in 1746, are unknown to him.

Jean-Baptiste-Siméon Chardin
1699–1779

67 SHEET OF FIGURE STUDIES
Red chalk touched with white chalk. The sheet has been twice torn across.
$7^1/2 \times 8^5/8$ in. (19×21.9 cm.)
Collections: Earl of Warwick, Sotheby's sale, 17 June 1936 (75) as "School of Watteau"; purchased in 1936.
Literature: Parker, I, p. 235, no. 479.

At the Warwick sale no. 67 was mounted with another drawing by the same hand showing two seated women, one holding a fan. In the sale catalogue both drawings were wrongly described as being in black chalk. The attribution to Chardin is based on the similarity of handling between no. 67 and two drawings in Stockholm from the Tessin Collection, reproduced by Schonbrünner-Meder, *Albertina Publication*, pls. 914 and 1008.

Henri-Pierre Danloux
1753–1809

68 STUDIES OF A SPANIEL
Black chalk on blue paper.
$8 \times 13^1/8$ in. (20.4×33.4 cm.)
Inscribed, *Etude de chien pour le tableau/ du [illegible] P. Danloux*.
Collections: Presented by M. Jacques Mathey in 1952.

No. 68 appears to be a study for the dog in Danloux's painting *The Envied Glutton* reproduced from the engraving by Joseph Grozer in *Henri-Pierre Danloux et son Journal durant l'Emigration* by R. Portalis, 1910, facing p. 82. Danloux was in England for about ten years from the beginning of 1791.

Jean Charles Delafosse
1734–1789

69 AN URN
Pen with brown and grey wash.
9⅝×5½ in. (24.5×13.9 cm.)
Signed lower left, *J. C. Delafosse*.
Collections: W. R. Jeudwine; purchased in 1971.

J. C. Delafosse, architect and draughtsman, was one of the most prolific designers of ornament and decoration of his time.

Alexandre-François Desportes
1661–1743

70 STUDIES OF A DOG
Body color and wash on buff paper, slightly stained, within a ruled brown wash margin.
7⁹/₁₆×8⅝ in. (19.3×21.1 cm.)
Presented by M. Jacques Mathey in 1952.

Charles Eisen
1721–1778

71 SCENE IN A BALLROOM
Pen and bistre and india ink with watercolors and touches of body color (partly oxidized).
6½×8⁹/₁₆ in. (16×21.8 cm.)
Signed *C. E. fecit* in left lower corner.
Collections: Daniel Saint, sale, Paris, 4 May 1846 (11), attributed to Cochin; purchased in 1934.
Exhibitions: London, Royal Academy, *European Masters of the Eighteenth Century*, 1954–55 (569); and *France in the Eighteenth Century*, 1968 (220).
Literature: Parker, I, pp. 242–3, no. 489.

Jean-Honoré Fragonard
1732–1806

72 A SCENE FROM "DON QUIXOTE"
Pen and brush in bistre over black.
16²/₁₆×11½ in. (41.8×28.5 cm.)
Collections: Baron Vivant Denon; Henry Oppenheimer, sale, Christie's, 14 July 1936 (430).
Exhibitions: London, Royal Academy, *France in the Eighteenth Century*, 1968 (261).
Literature: R. Portalis, *Honoré Fragonard*, 1889, p. 299.

No. 72 belongs to a series of illustrations to *Don Quixote* which at one time belonged to Denon.

Romain Girard
b. *c.* 1751

73 DESIGN FOR A CANDLE BRACKET
Red chalk over a preliminary outline in black lead.
10¹³/₁₆×7¼ in. (27.6×18.4 cm.)
Collections: J. Carré; Alfred Morrison; purchased in 1934.
Exhibitions: Paris, Musée des Arts Décoratifs, *Exposition de dessins de maîtres anciens des arts décoratifs*, 1880 (264), as by J. A. Meissonnier.
Literature: L. Clément de Ris in *Gazette des Beaux-Arts*, XXII, 1880, deuxième période, p. 437, as Meissonnier; Mlle M. L. Bataille, as by Meissonnier in L. Dimier, *Les Peintres Français de XVIIIᵉ siècle*, II, 1930, p. 373, no. 19; Parker, I, p. 245, no. 497.

A design for a *bras d'appliqué* for two candles, almost certainly intended to be executed in ormolu.

Hubert-François Bourguignon, called Gravelot
1699–1773

74 A GENTLEMAN STANDING
Black and white chalks and stump on buff paper.
13 1/8 × 7 3/4 in. (33.4 × 19.7 cm.)
Collections: Francis Douce (by 1800), by whom bequeathed to the Bodleian Library, 1834; transferred to the University Galleries, 1863.
Literature: Parker, I, p. 246, no. 500.

Apparently drawn from the same model as no. 41.

Jean-Baptiste Greuze
1725–1805

75 SELF-PORTRAIT
Brush, india ink wash, on white paper.
6 1/4 × 5 1/4 in. (15.7 × 13.4 cm.)
Inscribed on an old label from the back of the former frame, *J. B. Greuze peint / par lui-même à l'âge / de 31 ans / donné par Mme Trognon /le 30 decembre 1854,* and in another hand, *Donné par M. Henriquet-Dupont / le 18 octobre 1887.*
Engraved by J. J. Flipart, 1763.
Collections: Madame Trognon, Paris, 1854; L. Trilha sale, Paris, December 1876, bt. G. Duplessis; Henriquet-Dupont, Paris, 1887; Adrien Fauchier-Magnan, Sotheby's sale, 4 December 1935, lot 22; P. & D. Colnaghi, London; T. H. Cobb, London; K. T. Parker, by whom presented in 1947.
Exhibitions: London, Royal Academy, *France in the Eighteenth Century,* 1962 (322); Hartford, Wadsworth Atheneum, San Francisco, California Palace of the Legion of Honor, and Dijon, Musée des Beaux-Arts, *Jean-Baptiste Greuze,* 1976–77 (36).
Literature: John Smith, *Catalogue raisonné of the works of the most eminent Dutch, Flemish and French Painters,* VIII, 1837, p. 400, no. 1; J. Martin and C. Masson, *Catalogue raisonné de l'oeuvre peint et dessiné de J. B. Greuze,* Paris, 1908, no. 1150.

Jean-Baptiste Hilair
1753–1822

76 AN ARMENIAN IN NATIONAL DRESS
Watercolor over pencil.
12 9/16 × 6 15/16 in. (31.9 × 17.6 cm.)
Inscribed in pencil top right *Arme* (Armenian), suggesting that the drawing has been cut.
Collections: R. W. Alston; F. A. Drey; presented anonymously, 1942.

Hilair accompanied Count Choiseul-Gouffier on a journey to the Levant and Turkey in 1776. He made numerous illustrations for Choiseul-Gouffier's *Voyage Pittoresque de la Grèce* (1782) and for Mouradgea d'Ohsson's *Tableau de L'Empire Ottoman* (1780).

Jean-Baptiste Huet
1745–1812

77 HEAD OF A GIRL (? A MUSE)
Brush in grey and pink watercolors over black lead.
7 × 5 11/16 in. (17.1 × 14.5 cm.)
Signed *J. B. Hüet 1777* in lower left corner.
Collections: Mr. L. C. G. Clarke, by whom presented in 1936.
Literature: Parker, I, p. 251, no. 514.

78 TWO STUDIES OF A PUMPKIN
Watercolors.
9 15/16 × 14 1/2 in. (25.2 × 36.3 cm.)
Signed *J. B. Hüet 1785.*

Collections: P. M. Turner, by whom presented in 1942.
Exhibitions: London, Royal Academy, *France in the Eighteenth Century*, 1968 (345).

Nicolas Lancret

1690–1743

79 A GIRL ON A SWING ASSISTED BY A YOUNG MAN
Red chalk.
$7^{1}/_{16} \times 4^{11}/_{16}$ in. (18×12 cm.)
Inscribed lower right in black lead, *Lancret.*
Purchased in 1941.

The motif does not occur in any picture in G. Wildenstein's monograph, *Lancret* (1924).

Nicolas-Bernard Lépicié

1735–1784

80 PORTRAIT OF AN OLD LADY
Black and red chalks.
$5^{1}/_{16} \times 4^{1}/_{2}$ in. (12.9×11.5 cm.)
Signed *Lépicié del.*
Purchased in 1937.
Literature: Parker, I, p. 254, no. 522. There is an entry in the *Catalogue raisonné de l'oeuvre peint et dessiné de N.-B. Lépicié*, published by P. Gaston-Dreyfus and F. Ingersoll-Smouse in *Bulletin de la Société de L'Histoire de L'Art*, 1922, p. 237, no. 359, for a drawing (Vente Cambray, 28 November 1895 [394]) which could be no. 78, but insufficient detail is given for this to be certain.

Jean-Étienne Liotard, attributed to

1702–1789

81 STUDY OF A WOMAN IN PROFILE TO RIGHT
Red and black chalk.
$8^{5}/_{8} \times 5^{1}/_{4}$ in. (21.9×13.1 cm.)
Purchased in 1945.

Parker now inclines to attribute no. 81 to Antoine de Favray (1706–1791/92).

Charles-Joseph Natoire

1700–1777

82 VIEW FROM THE NORTH SIDE OF THE PALATINE AT ROME
Pen and bistre with watercolors and body color over red and black chalks on grey paper.
$11^{3}/_{4} \times 18^{5}/_{16}$ in. (30×46.5 cm.)
Inscribed by the artist below on left *Villa Farnese* and signed *C. Natoire 15 octob. 1764.*
Purchased in 1936.
Exhibitions: London, Royal Academy, *France in the Eighteenth Century*, 1968 (483).
Literature: Parker, I, p. 259, no. 533.

One of the many landscape drawings produced by Natoire between 1756 and 1776 (the greater number between 1760 and 1766) during his term of office as Director of the French Academy, 1751–76. A number are in the Musée Atger, Montpellier.

Jean-Baptiste Oudry

1686–1755

83 HEAD OF A FOX
Red, black, and white chalks.
$11^{9}/_{16} \times 12$ in. (29.5×30 cm.)
Purchased in 1952.

Other studies of a fox are discussed by H. M. Opperman, "Some Animal Studies by Jean-Baptiste Oudry" in *Master Drawings*, vol. IV, 1966, no. 4, p. 384. No. 83 seems to relate fairly closely to the painting *A Fox in a Farmyard* in the Wallace Collection, London, one of a set of four painted in 1748 for M. de Trudaine for the Château de Montigny-Lencoup (Seine et Marne). There is a replica of this picture at Waddesdon Manor (National Trust), Buckinghamshire, England.

Bernard Picart
1673–1733

84 GROUP OF FIGURES FOR A FÊTE GALANTE
Red chalk.
7¹/₂ × 11¹/₂ in. (19.1 × 29.3 cm.)
Inscribed (possibly a signature) in black lead, *B. Picart f 1708* in left lower corner and lower right (in the hand of the owner?), *15 Jan. 1776*.
Collections: Davidson; purchased in 1934.
Exhibitions: London, Royal Academy, *European Masters of the Eighteenth Century*, 1954–55 (437); *France in the Eighteenth Century*, 1968 (558).
Literature: Parker, I, p. 263, no. 544.

The two figures occur on the left of an engraving of a composition of eleven figures making music in the park of a château, inscribed *Inventé et Gravé par B. Picart en 1709*. It is accompanied by the following verse:

A l'ombre des bosquets dans un beau jour d'Eté
Cette agréable compagnie
Goute le doux plaisir que donne l'harmonie
Lorsque tout est bien concerté
Mais parmi les attraits d'une belle musique
Ou de Batiste ou de Lambert
L'amour tient sa partie et très souvent se pique
De faire que deux coeurs soupirent de concert.

Hubert Robert
1733–1808

85 THE FORUM OF TRAJAN, ROME
Pen and brown ink with watercolor over indications in pencil.
13 × 9⁹/₁₆ in. (33 × 24.2 cm.)
Collections: Richard Owen, Paris; Alan D. Pilkington, by whom bequeathed in 1973 in memory of his wife, Florence Mary.
Exhibitions: London, P. & D. Colnaghi, *Old Master Drawings*, 1953 (47); London, Royal Academy, *Drawings by Old Masters*, 1953 (417).

Antoine Watteau
1684–1721

86 TWO MUSICIANS
Red and white chalks on light brownish paper.
10¹/₄ × 14³/₁₆ in. (26 × 36.1 cm.)
Collections: Uvedale Price, Sotheby's sale, 4 May 1854 (305); Chambers Hall, by whom presented to the University Galleries, 1855.
Exhibitions: London, Royal Academy, *France in the Eighteenth Century*, 1968 (773).
Literature: S. Colvin, *Drawings in the University Galleries*, vol. III, 1907, pl. 41; K. T. Parker, *Antoine Watteau*, 1931, p. 11, no. 67; Parker, I, p. 268, no. 557; K. T. Parker and J. Mathey, *Antoine Watteau. Catalogue complet de son oeuvre dessiné*, II, 1957, p. 365, no. 857, fig. 857.

The two figures recur in the painting *La Contredanse* which passed from the collection of Sir Hugh Lane to the Sterling Postley Collection, New York.

87 ''LE NAUFRAGE'':
AN ALLEGORY
Red chalk.
8³/₄ × 13⁵/₁₆ in. (22.2 × 33.9 cm.)
Collections: Francis Douce, by whom be-
queathed to the Bodleian Library, 1834;
transferred to the University Galleries,
1863.
Exhibitions: London, Royal Academy,
France in the Eighteenth Century, 1968
(772).
Literature: S. Colvin, *Drawings in the
University Galleries*, 1907, pl. 39; E.
Dacier and A. Vuaflart, *Jean de Jullienne
et les Graveurs de Watteau*, I, 1929, p.
102; Parker, I, p. 269, no. 559; Parker–
Mathey, *op. cit.*, II, p. 365, no. 853, fig.
853.

The drawing was engraved in reverse by
Count Caylus and included in Jean de Jul-
lienne's *Oeuvre gravé de Watteau*. There is
general agreement that the subject alludes
to the collapse of John Law's "Western
Company" in Paris in 1720. Jean de Jul-
lienne who stands r. assisting Watteau him-
self ashore, is said to have saved the painter
6,000 livres "du naufrage." The drawing
may therefore be dated with certainty to
the year 1720.

88 HEAD OF A BOY
Red and black chalks.
5⁷/₈ × 5³/₁₆ in. (14.9 × 13.2 cm.)
Purchased in 1937.

Exhibitions: London, Matthiesen Gallery,
*French Master Drawings of the Eighteenth
Century*, 1950 (100).
Literature: Parker, I, p. 269, no. 558; Par-
ker–Mathey, *op. cit.*, II, p. 232, no. 693,
fig. 693.

Parker observes that the shadows fall in
such a way as to suggest that no. 88 may
have been drawn by candlelight. The
drawing seems to have served for the head
of the fiancé in *Le Contrat de Marriage* in
the Prado, Madrid.

89 A LITTLE OLD MAN IN
CLOAK AND BROAD-
BRIMMED HAT
Red chalk.
8¹¹/₁₆ × 5³/₄ in. (21.8 × 14.5 cm.)
Presented by Mr. K. T. Parker in 1948.
Literature: J. Mathey, "Diversité de Wat-
teau dessinateur" in *Connaissance des
Arts*, September, 1957, p. 66; Parker–
Mathey, *op. cit.*, II, p. 379, no. 920, fig.
920.

Several small, caricature drawings of a
Goya-like quality, to which group no. 89
belongs, are recorded by Parker–Mathey,
nos. 919–924.

Illustrations

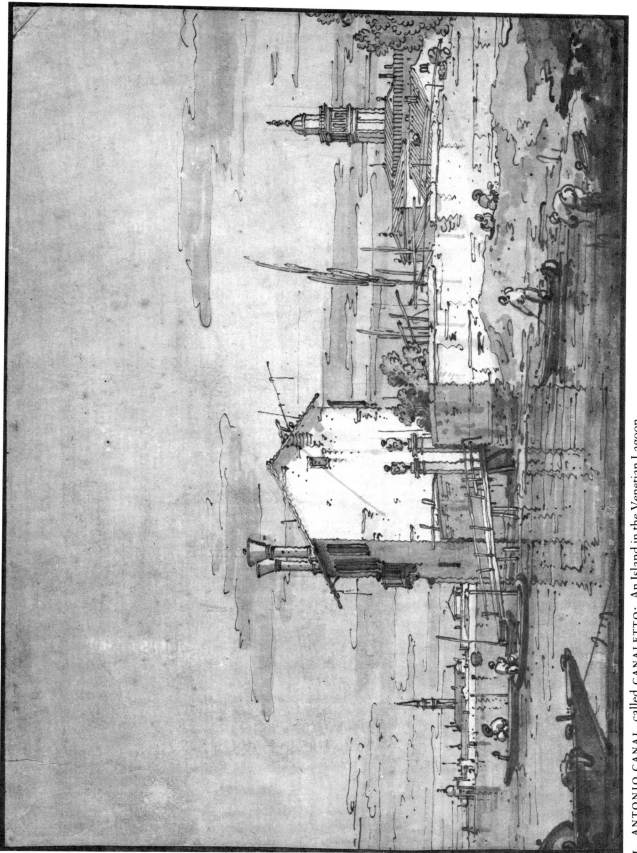

1. ANTONIO CANAL, called CANALETTO: An Island in the Venetian Lagoon

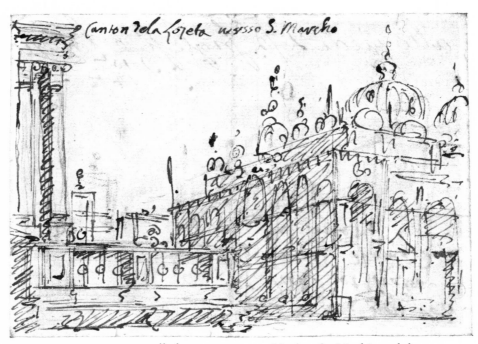

2. ANTONIO CANAL, called CANALETTO: Venice: St. Mark's and the
Loggetta

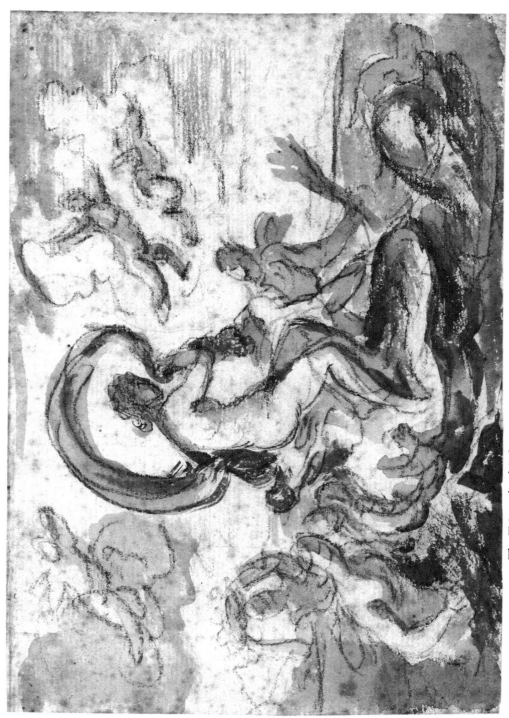

3. PAOLO DE MATTEIS: The Triumph of Galatea

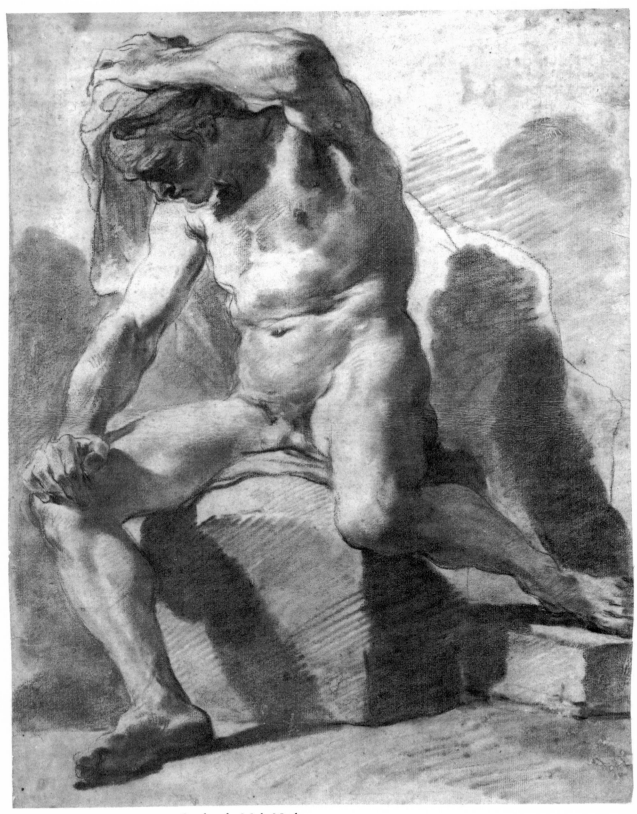

4. GAETANO GANDOLFI: Study of a Male Nude

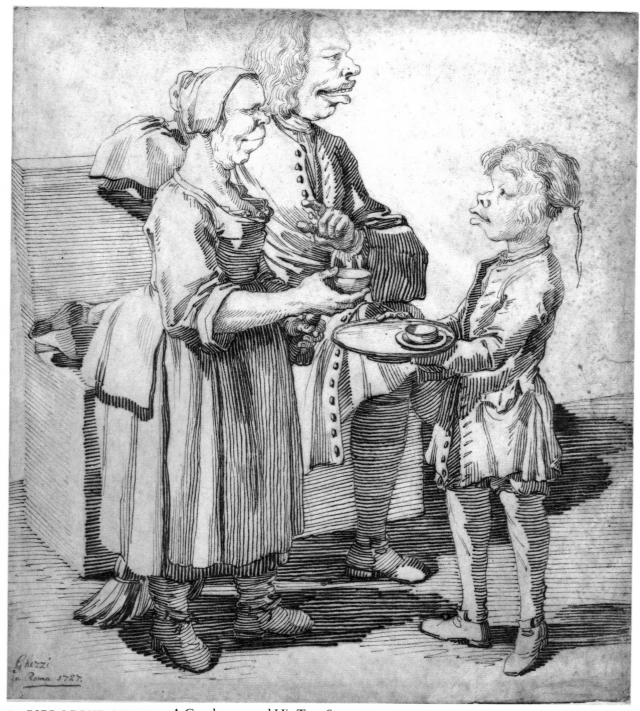

5. PIER LEONE GHEZZI: A Gentleman and His Two Servants

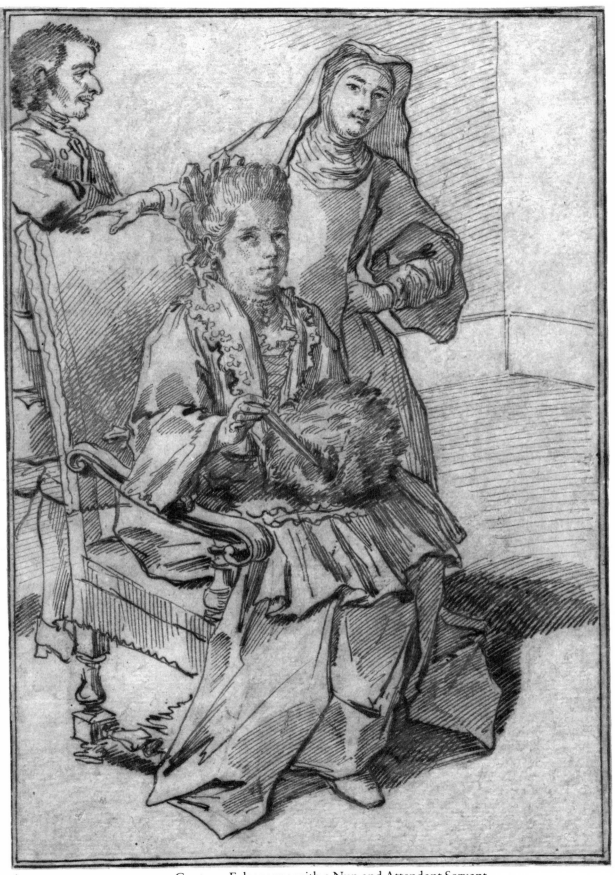

6. **PIER LEONE GHEZZI:** Contessa Falsacappa with a Nun and Attendant Servant

7. ANTONIO GIONIMA: Cleopatra Dissolving the Pearl

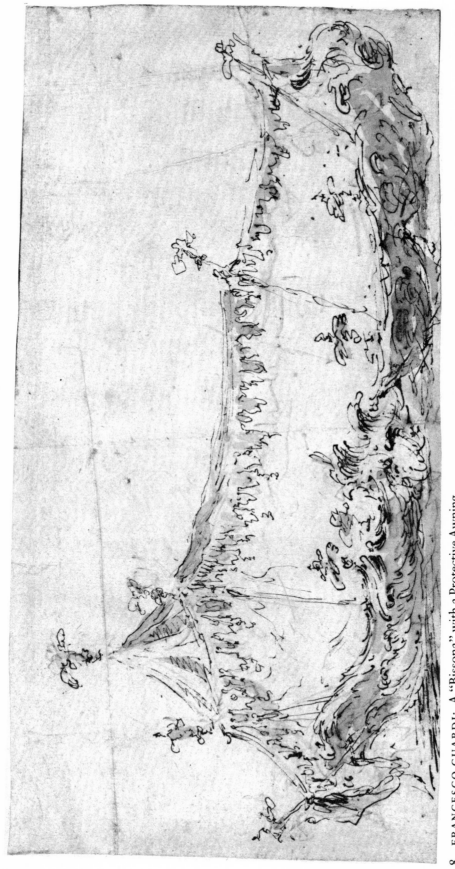

8. FRANCESCO GUARDI: A "Bissona" with a Protective Awning

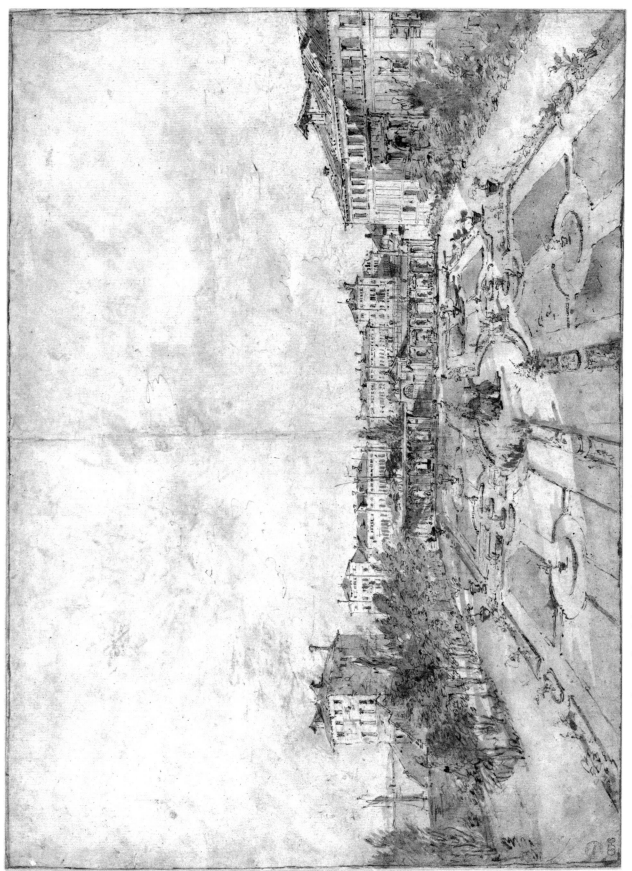

9. FRANCESCO GUARDI: The Garden of the Palazzo Contarini del Zaffo, Venice

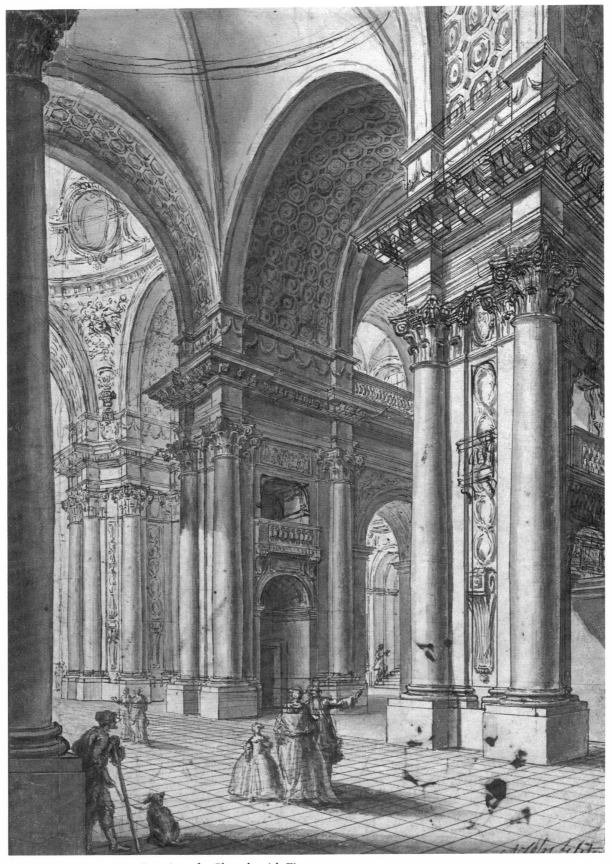

10. ANTONIO JOLI: Interior of a Church with Figures

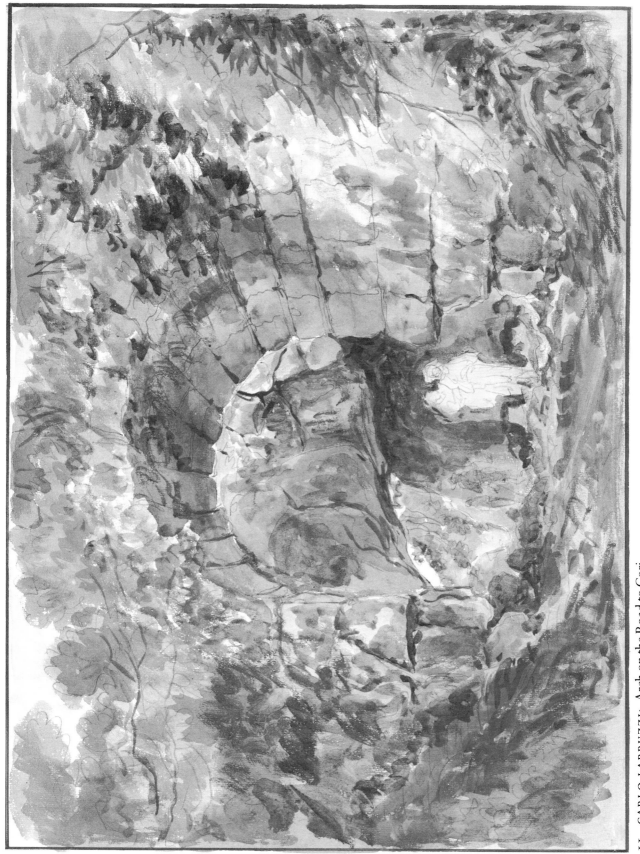

11. CARLO LABRUZZI: Arch on the Road to Cori

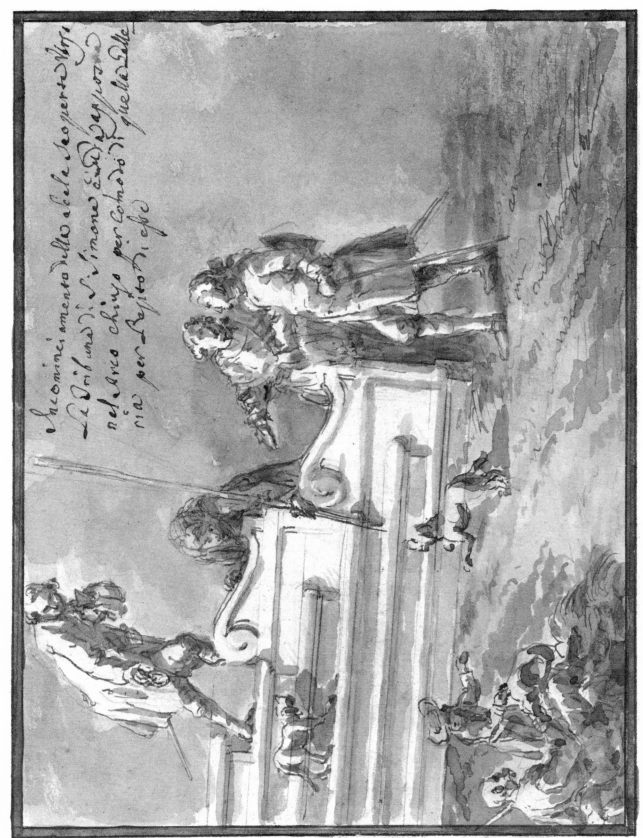

12. CARLO MARCHIONNI: The Foot of a Flight of Stairs

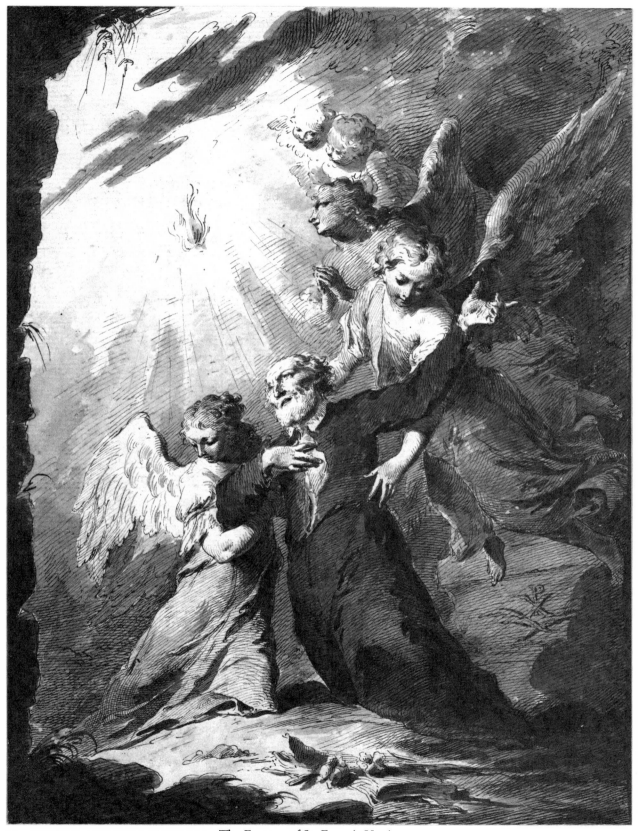

13. PIETRO ANTONIO NOVELLI: The Ecstasy of St. Francis Xavier

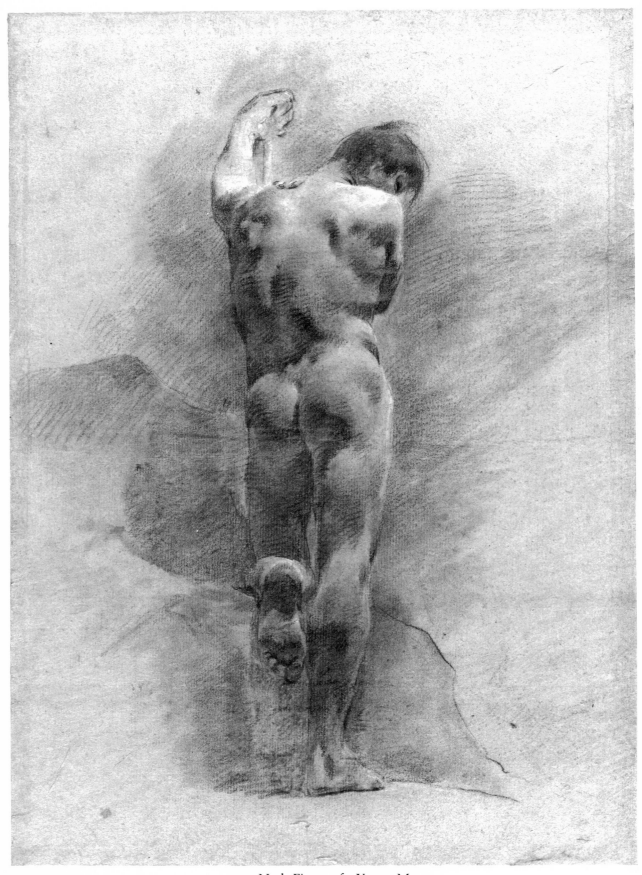

14. GIOVANNI BATTISTA PIAZZETTA: Nude Figure of a Young Man

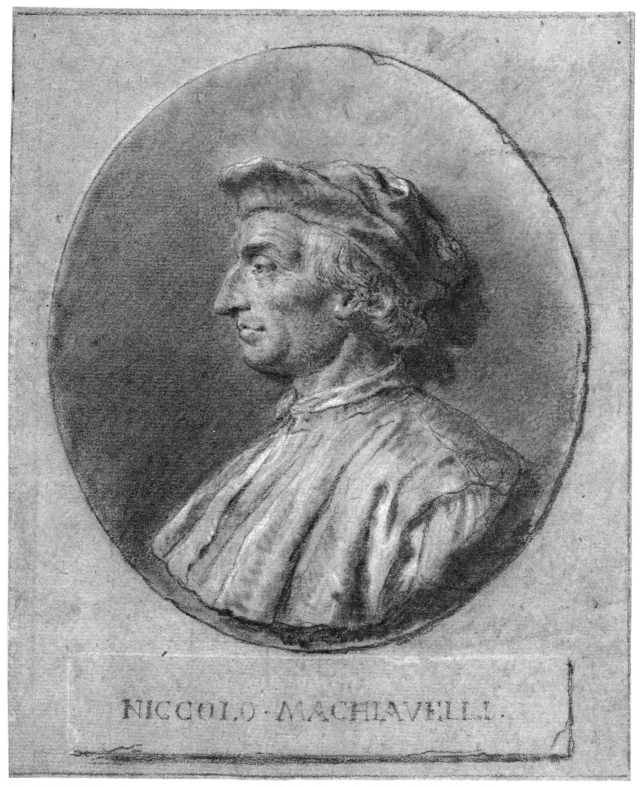

NICCOLO · MACHIAVELLI ·

15. GIOVANNI BATTISTA PIAZZETTA: Medallion Portrait of Niccolò Machiavelli

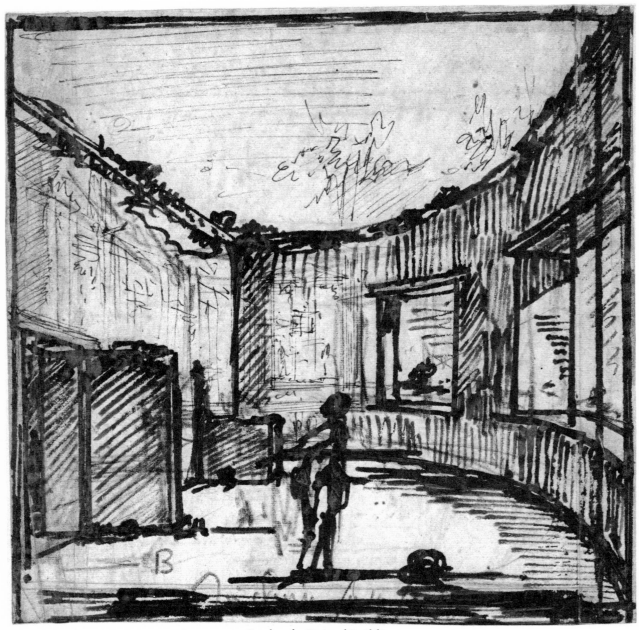

17. GIOVANNI BATTISTA PIRANESI: Study of a Ruined Building

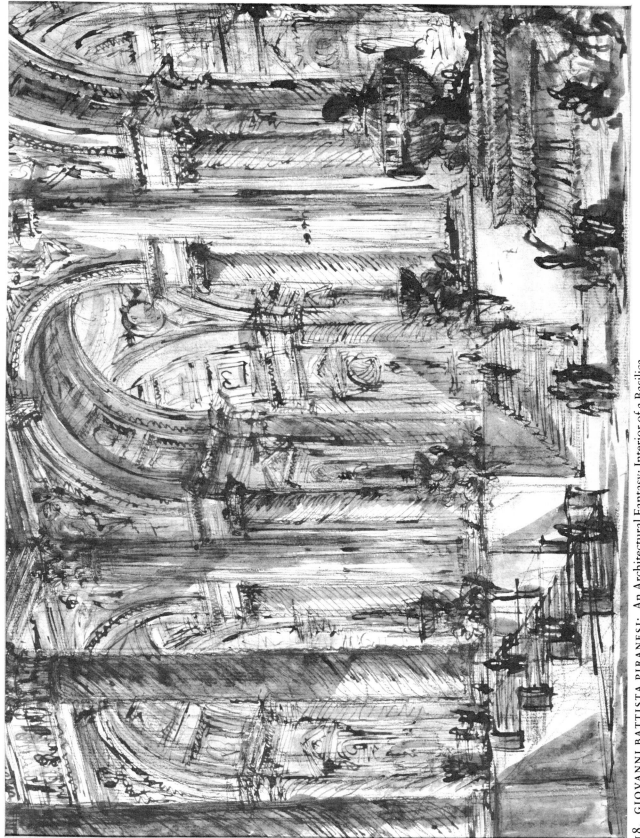

18. GIOVANNI BATTISTA PIRANESI: An Architectural Fantasy: Interior of a Basilica

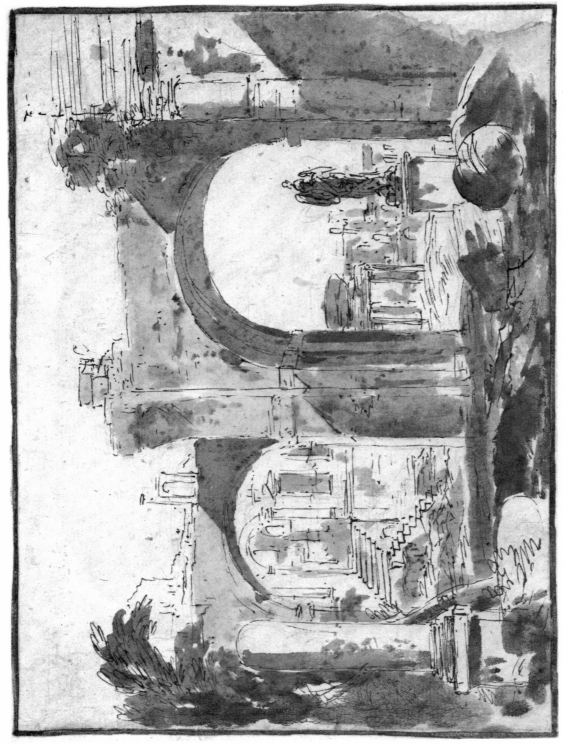

19. MARCO RICCI: Classical Ruins with a Column Rising in Front to Left and a Statue Seen through an Arch to Right

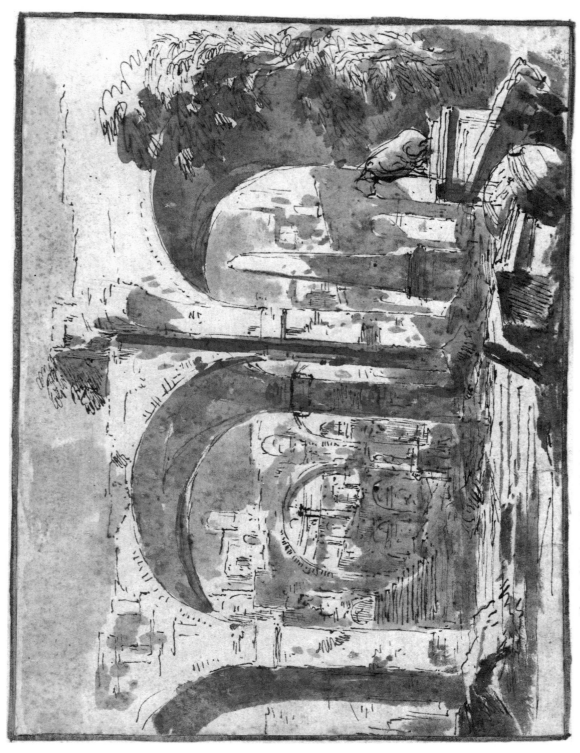

20. MARCO RICCI: Classical Ruins with an Obelisk Seen through an Arch to Right and with the Statue of a ?Lion in the Foreground to Right, Its Pedestal Rising above Fallen Masonry

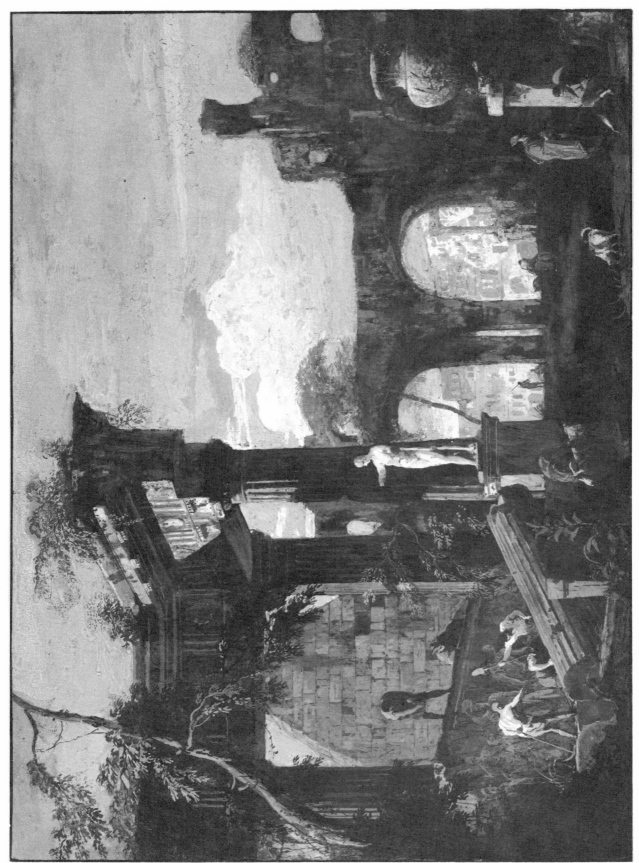

21. MARCO RICCI: A Classical Capriccio

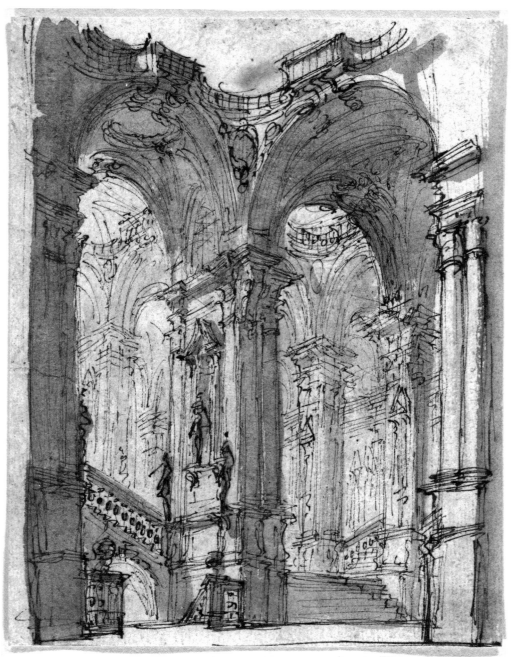

22. MAURO ANTONIO TESI: Architectural Fantasy: A Monumental Stairway
Viewed through Arches

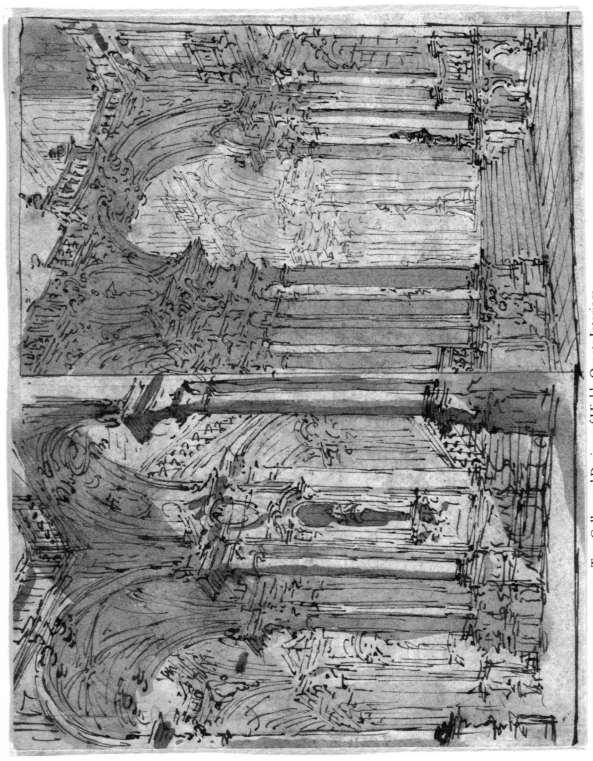

23. MAURO ANTONIO TESI: Two Collocated Designs of Highly Ornate Interiors

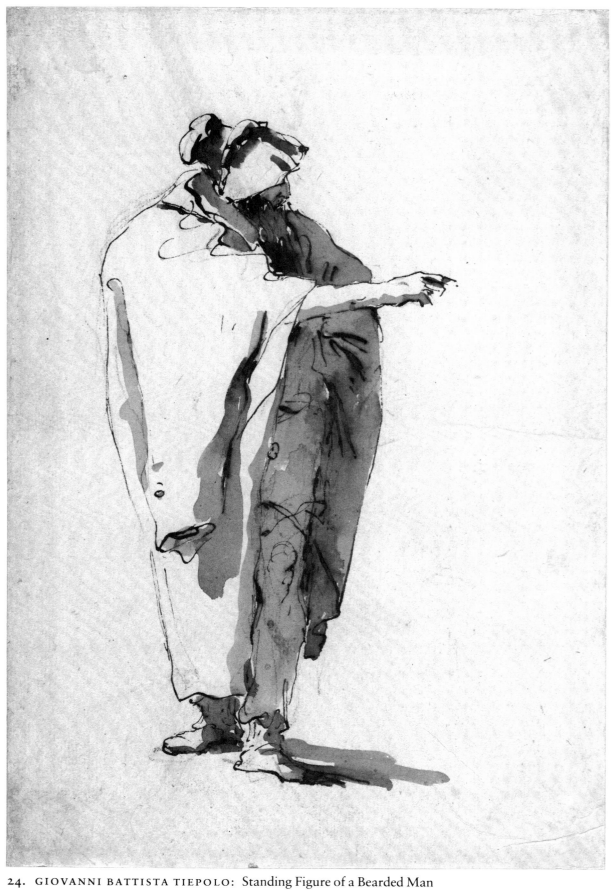

24. GIOVANNI BATTISTA TIEPOLO: Standing Figure of a Bearded Man

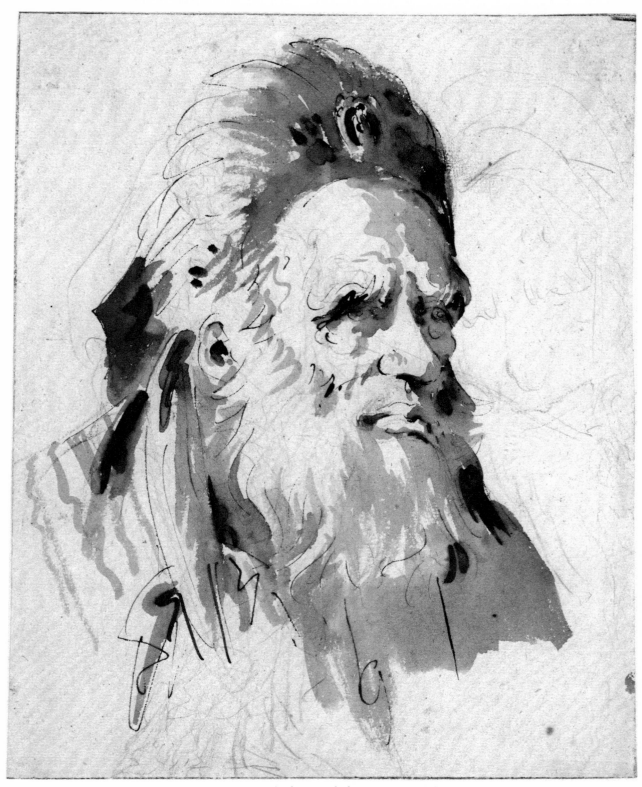

25. GIOVANNI BATTISTA TIEPOLO: Head of a Bearded Man in a Fur Cap

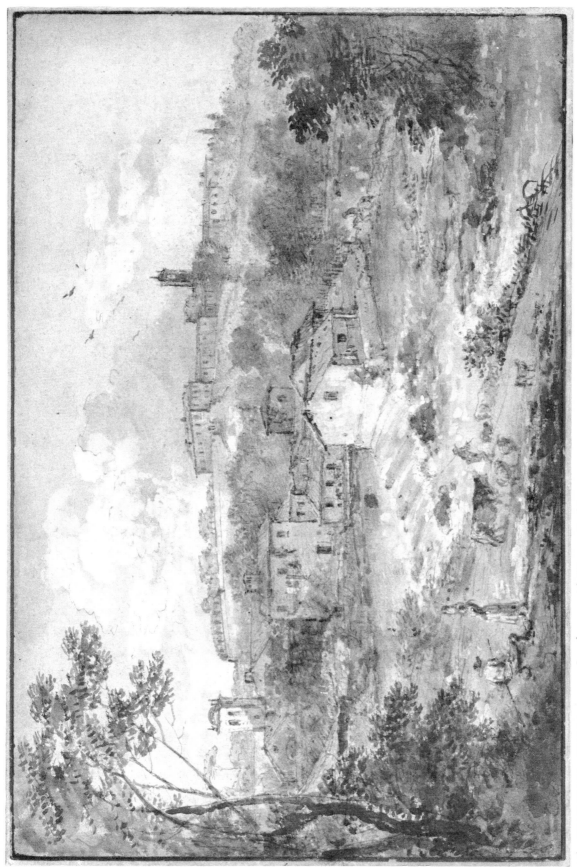

26. FRANCESCO ZUCCARELLI: Landscape with Women Bathing

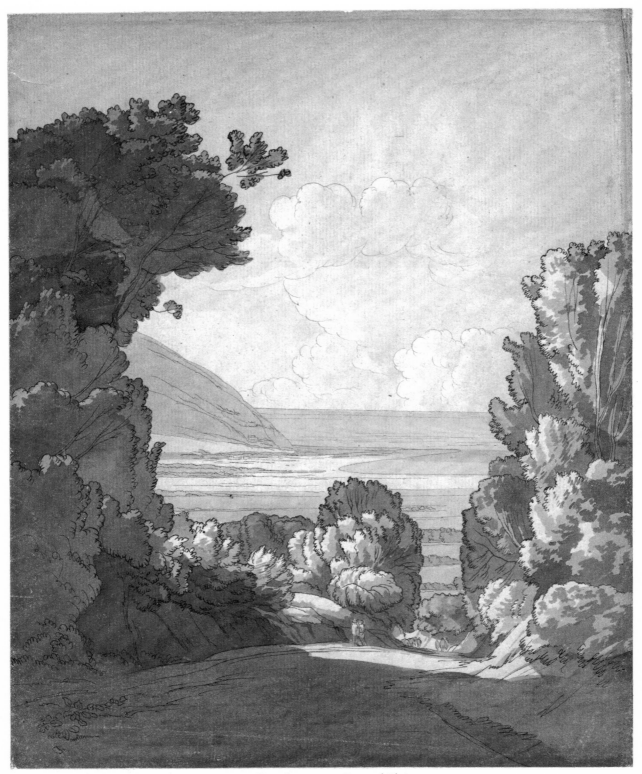

27. JOHN WHITE ABBOTT: A Lane Leading down to a Coastal Plain

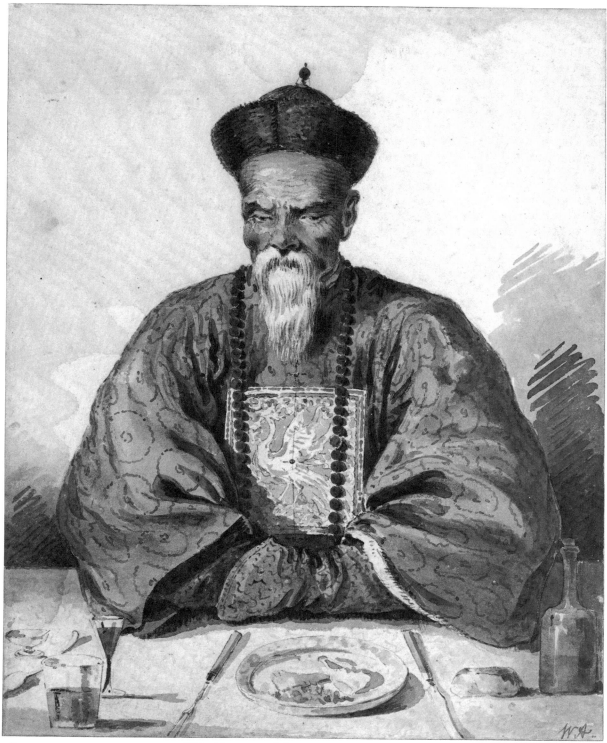

28. WILLIAM ALEXANDER: "The Fou-yen of Canton"

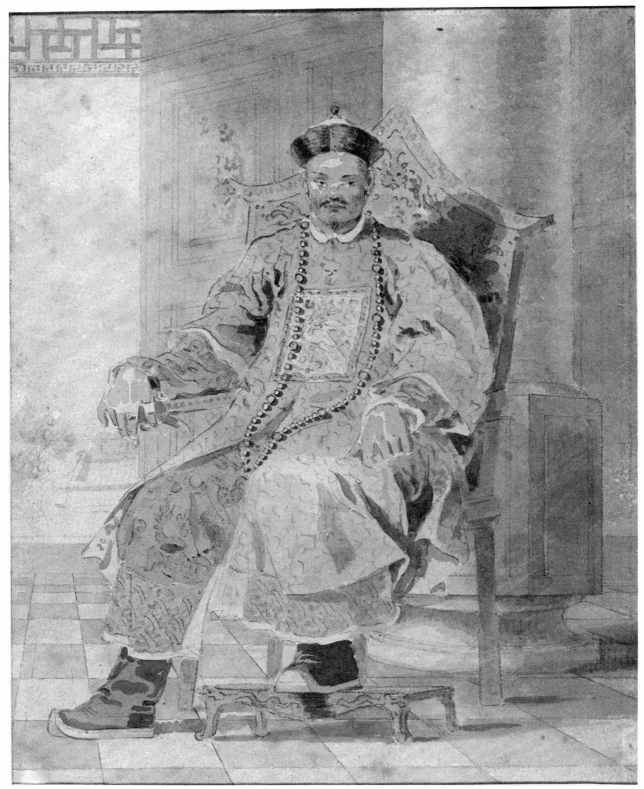

29. WILLIAM ALEXANDER: Portrait of Ch'ien-Lung, Emperor of China

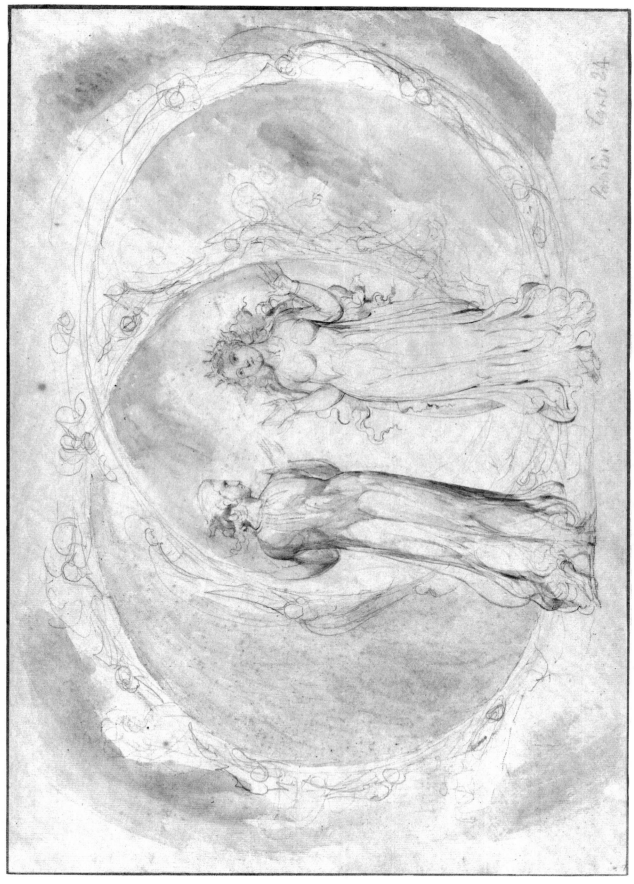

30. WILLIAM BLAKE: Beatrice and Dante in Gemini amid the Spheres of Flame

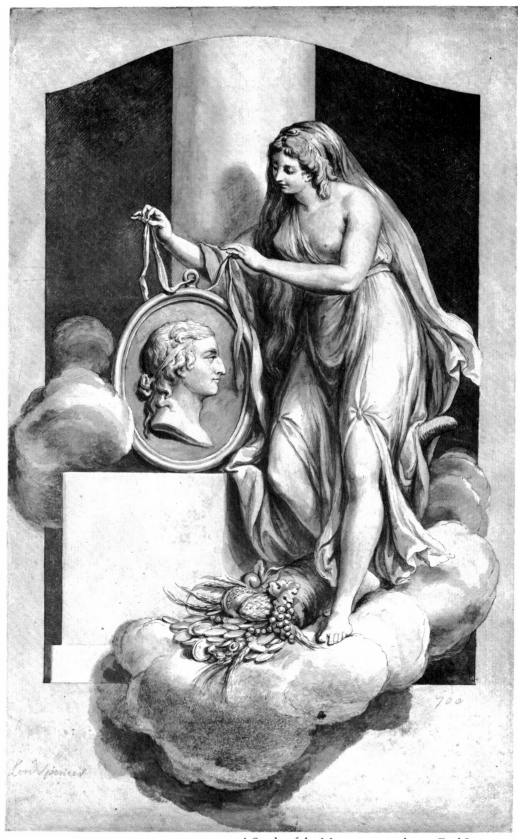

31. GIOVANNI BATTISTA CIPRIANI: A Study of the Monument to the 1st Earl Spencer (1734–1783) in the Church of St. Mary, Great Brington, Northamptonshire

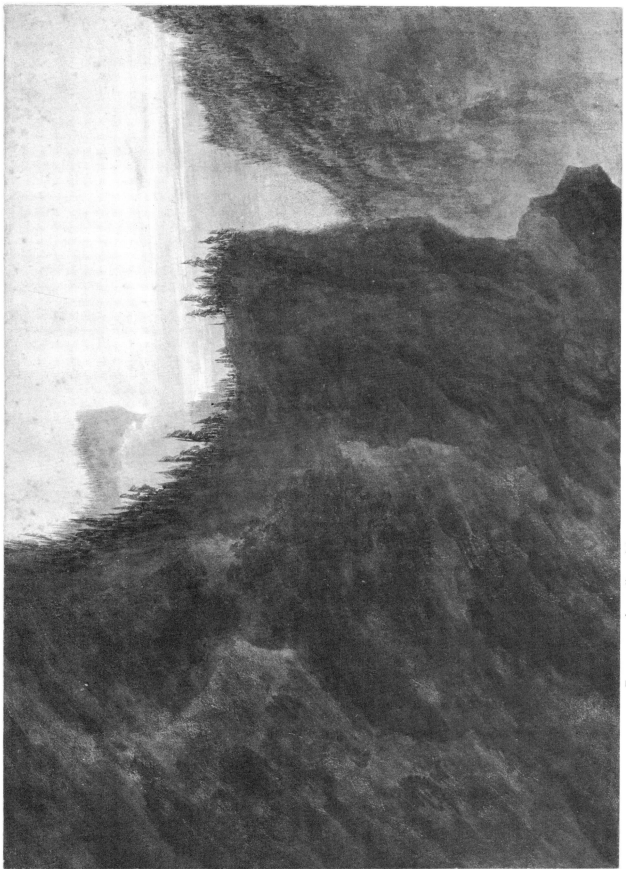

32. JOHN ROBERT COZENS: Entrance to the Valley of the Grande Chartreuse in Dauphiné

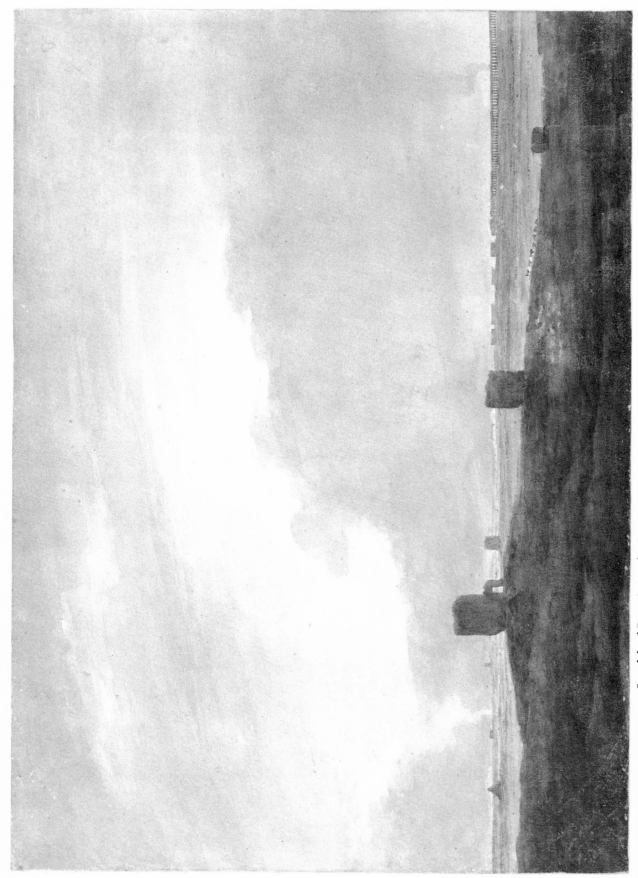

33. JOHN ROBERT COZENS: Sepulchral Remains in the Campagna

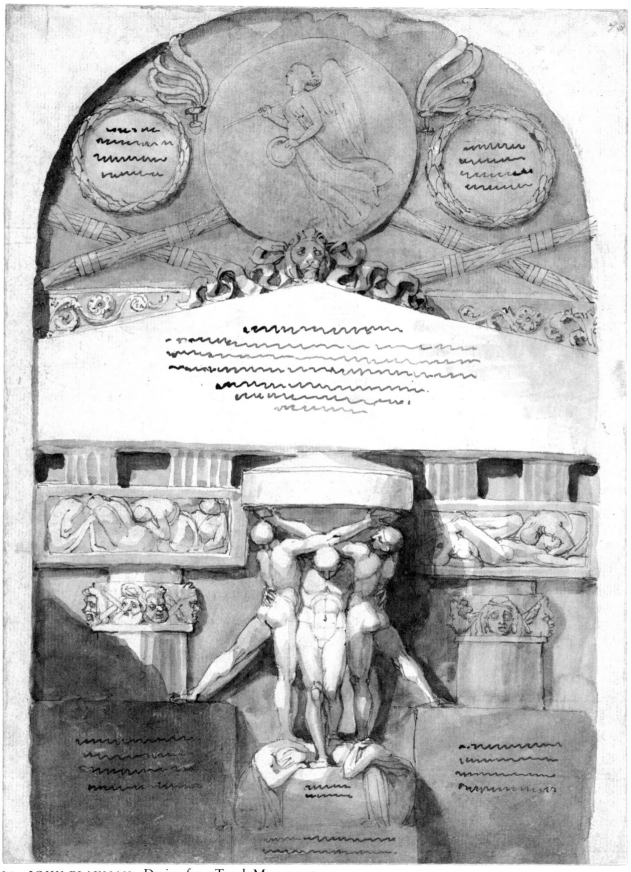

34. JOHN FLAXMAN: Design for a Tomb Monument

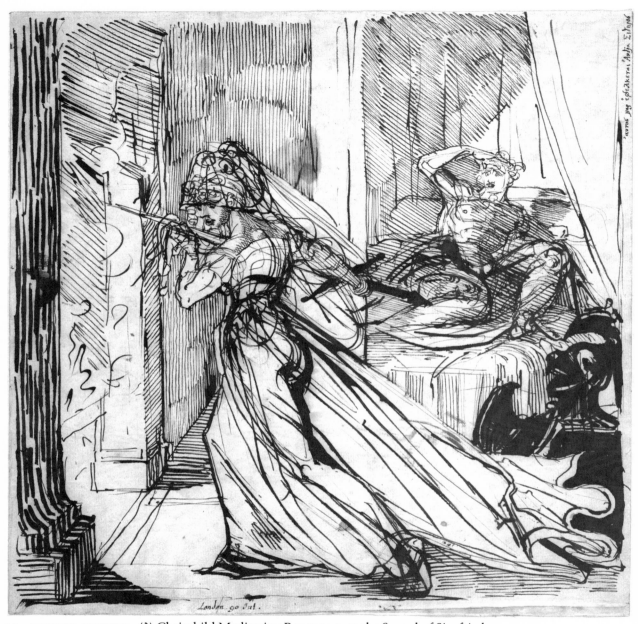

35. HENRY FUSELI: (?) Chrimhild Meditating Revenge over the Sword of Siegfried

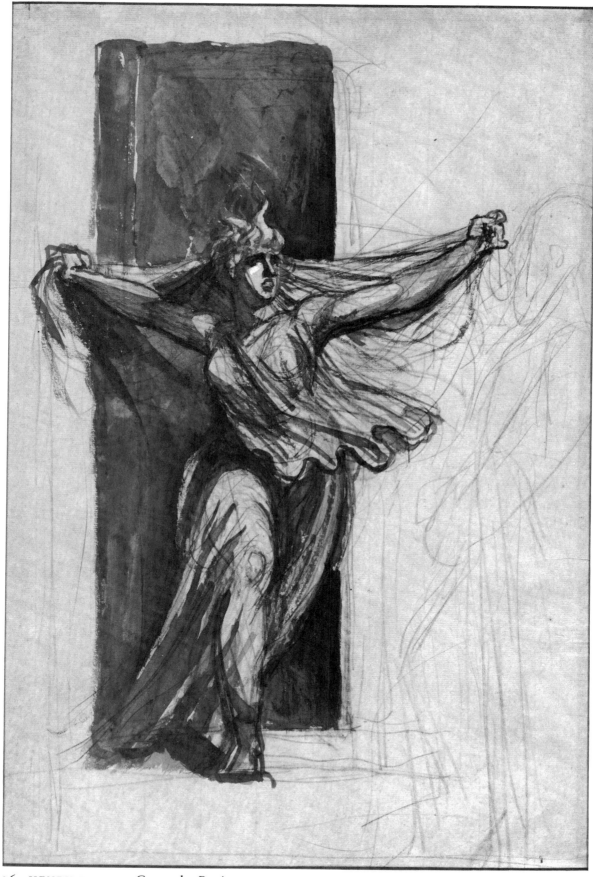

36. HENRY FUSELI: Cassandra Raving

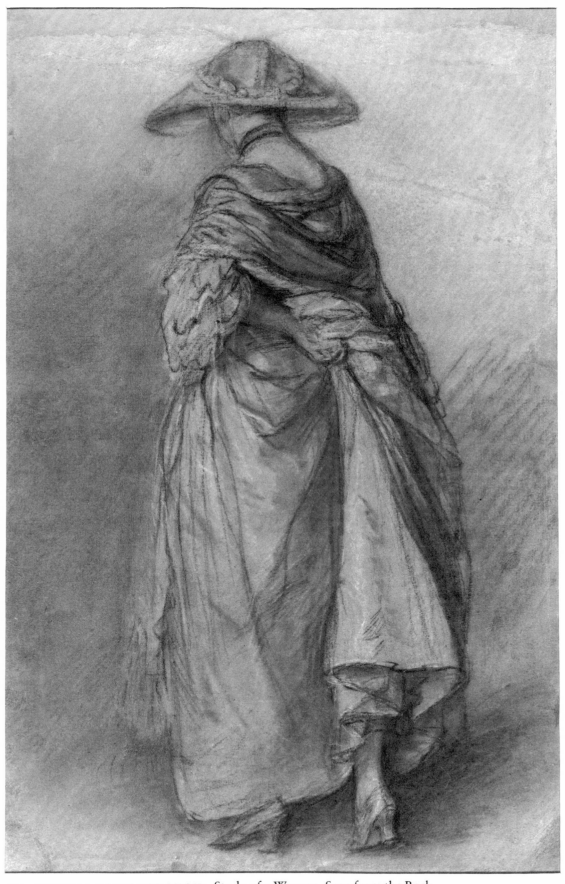

37. THOMAS GAINSBOROUGH: Study of a Woman, Seen from the Back

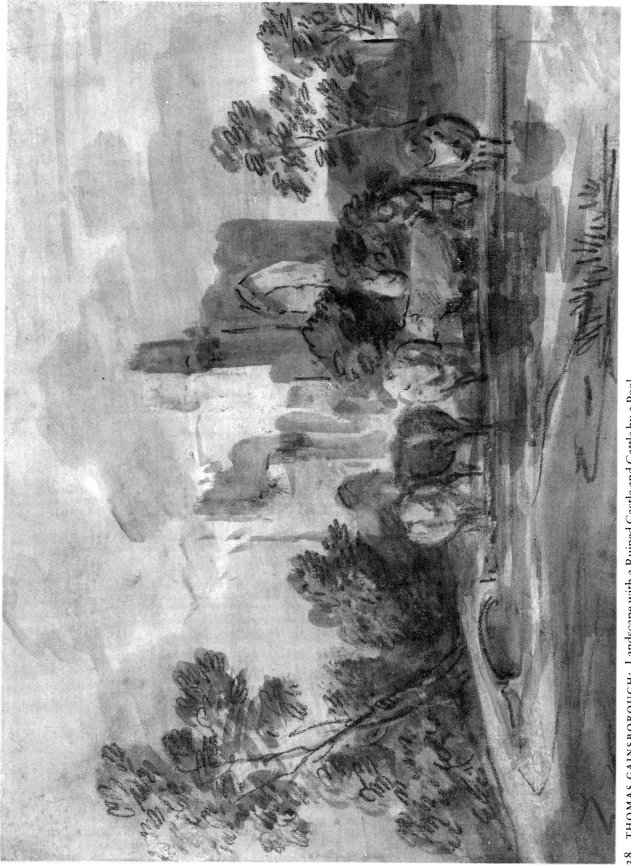

38. THOMAS GAINSBOROUGH: Landscape with a Ruined Castle and Cattle by a Pool

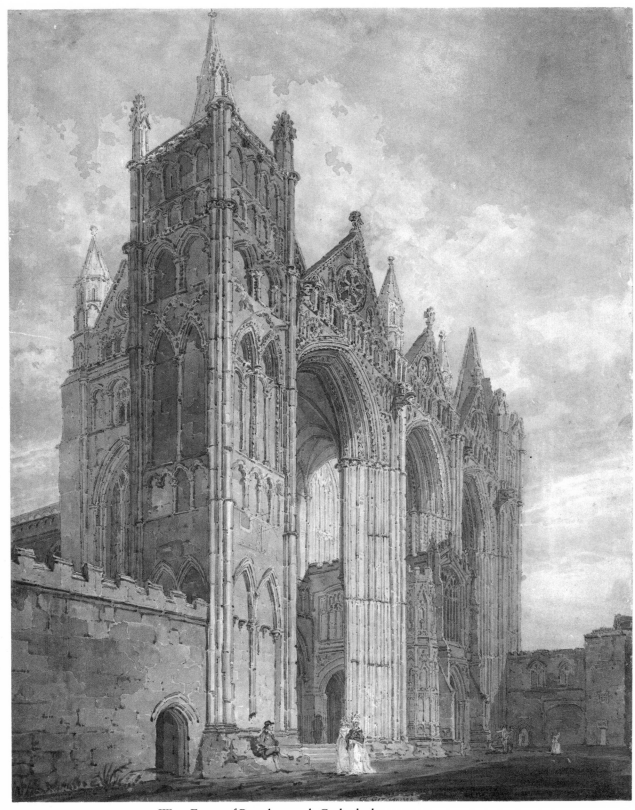

39. THOMAS GIRTIN: West Front of Peterborough Cathedral

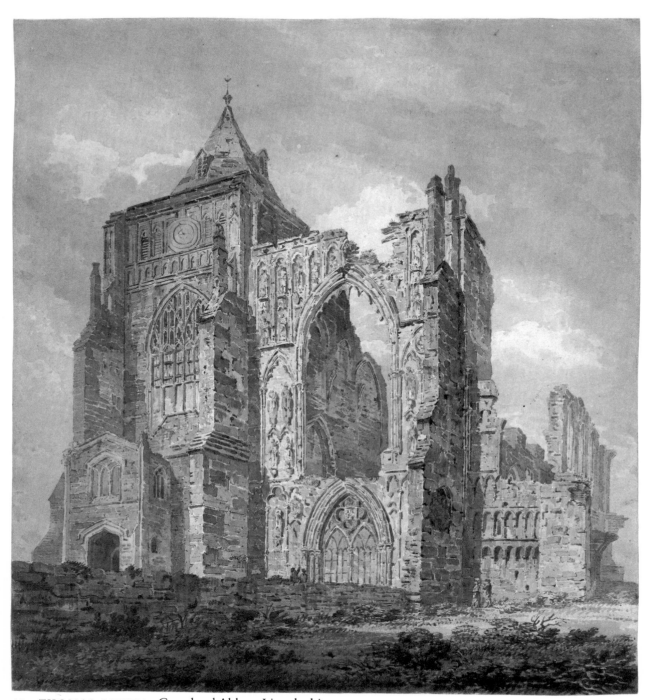

40. THOMAS GIRTIN: Crowland Abbey, Lincolnshire

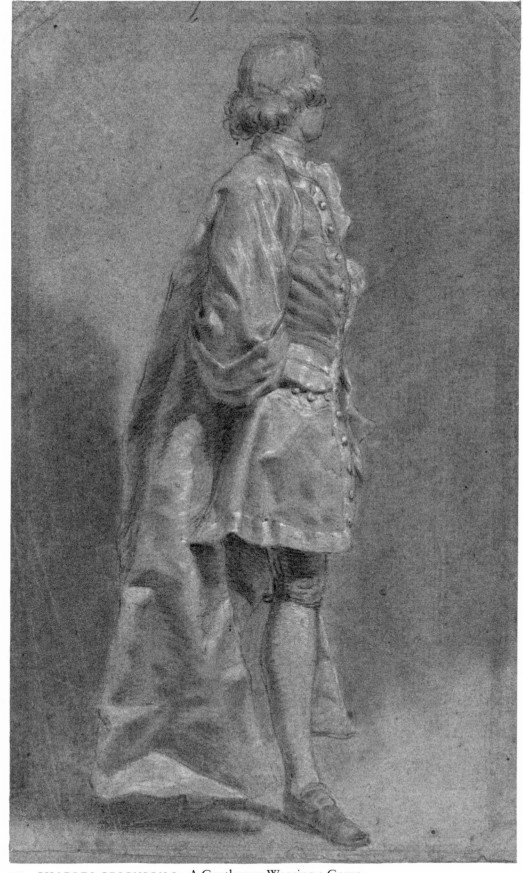

41. CHARLES GRIGNION I: A Gentleman Wearing a Gown

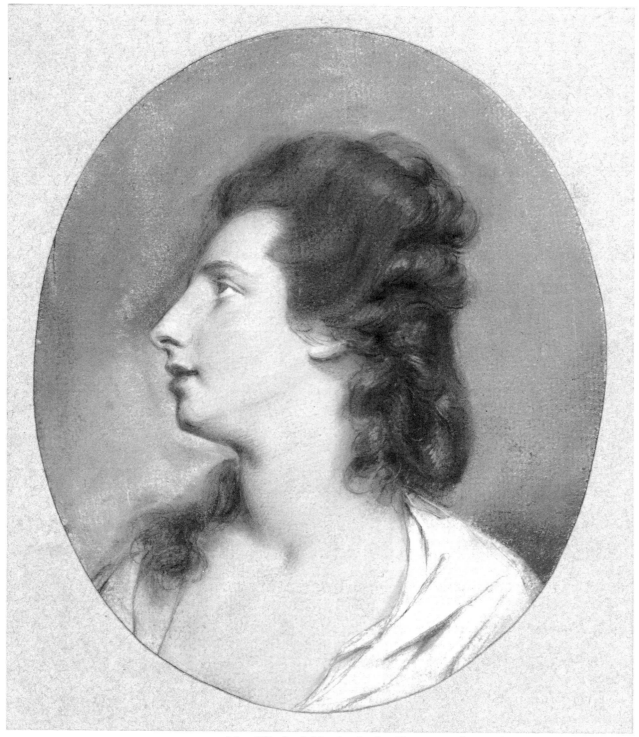

42. HUGH DOUGLAS HAMILTON: Mrs. Elizabeth Hartley in the Character of Jane Shore

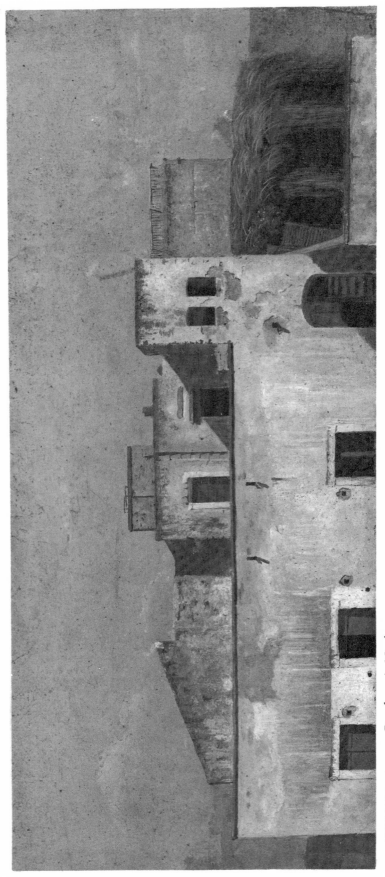

43. THOMAS JONES: Rooftops in Naples

44. MARCELLUS LAROON: "Cudgeling"

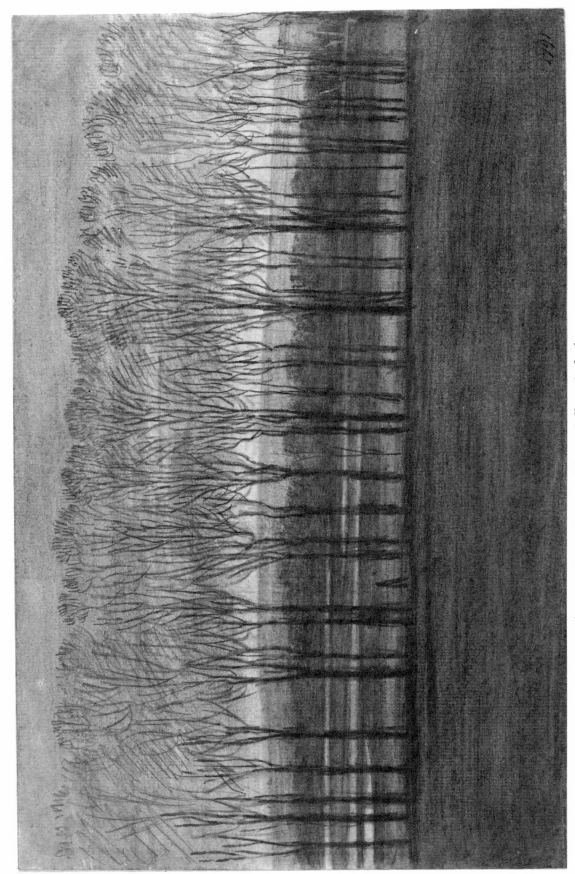

45. JOHN BAPTIST MALCHAIR: A View from Mr. Nare's Rooms at Merton College, Oxford

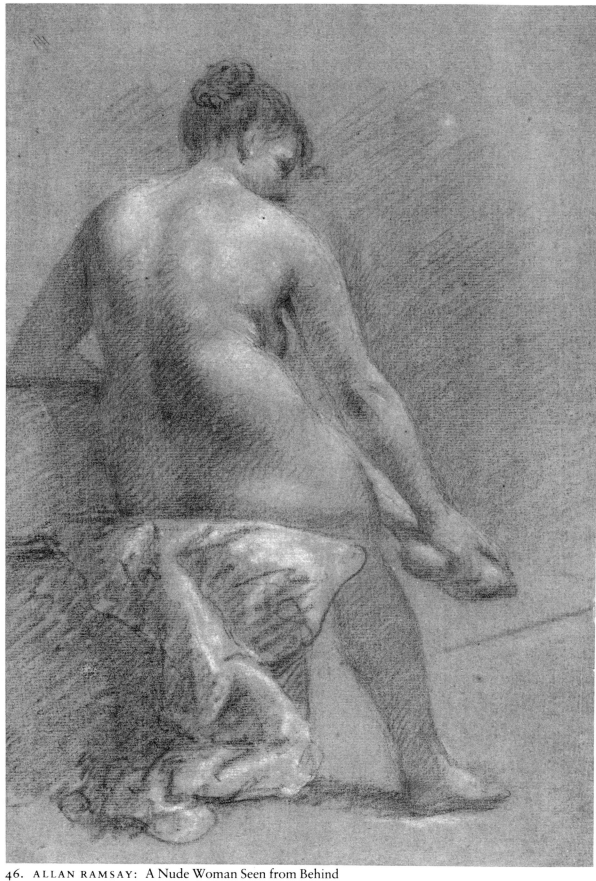

46. ALLAN RAMSAY: A Nude Woman Seen from Behind

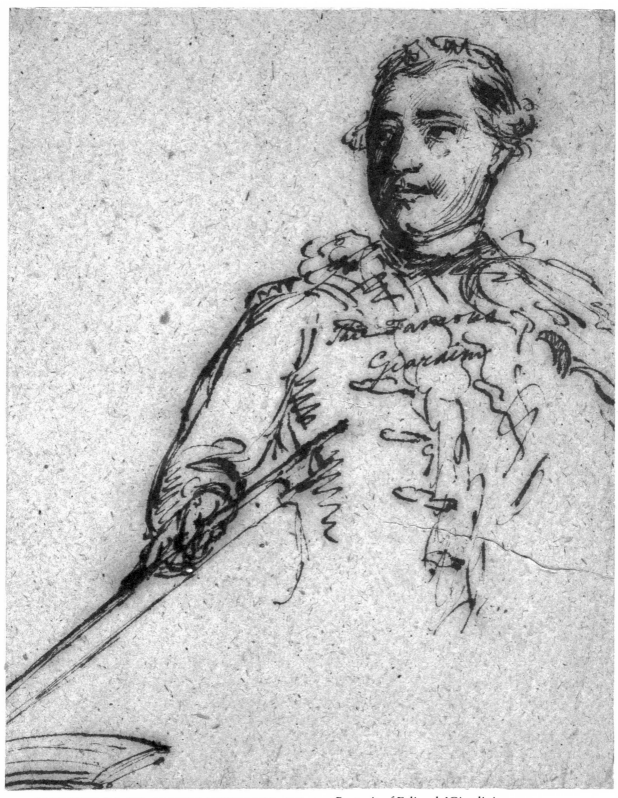

47. ASCRIBED TO SIR JOSHUA REYNOLDS, P.R.A.: Portrait of Felice de'Giardini

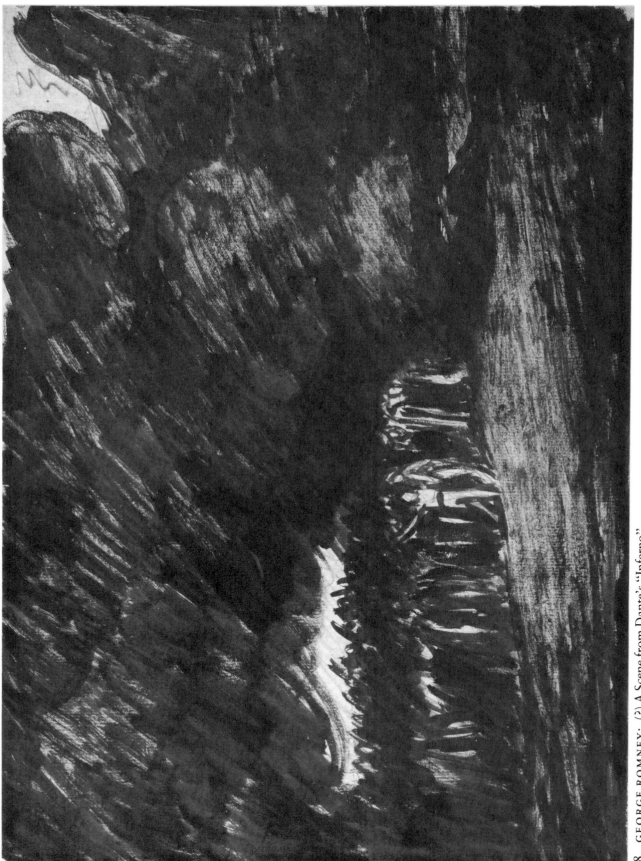

48. GEORGE ROMNEY: (?) A Scene from Dante's "Inferno"

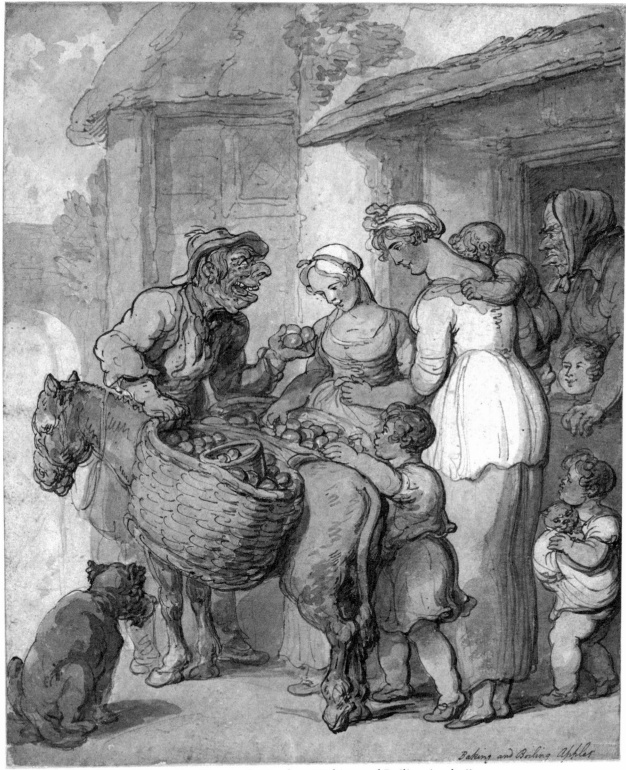

Baking and Boiling Apples

49. THOMAS ROWLANDSON: The Apple Vendor: "Baking and Boiling Apples"

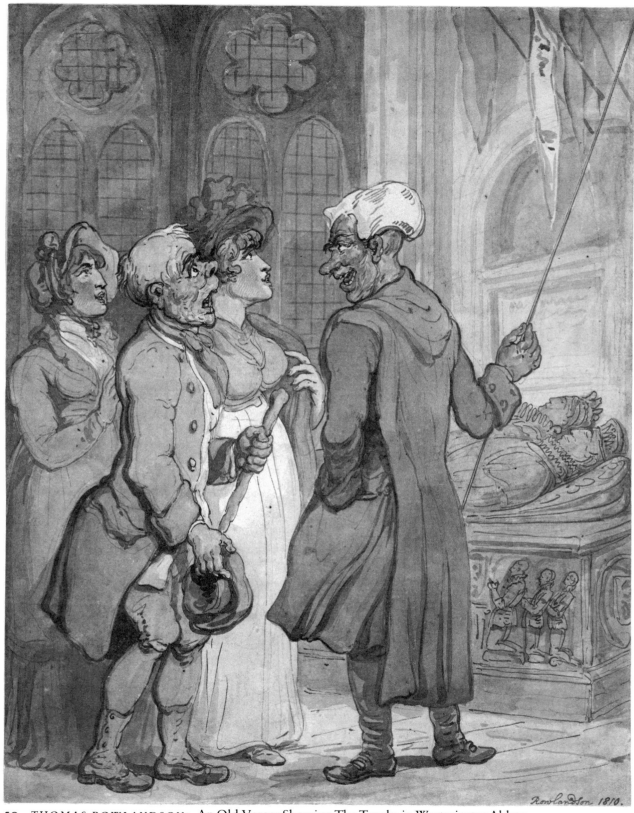

50. THOMAS ROWLANDSON: An Old Verger Showing The Tombs in Westminster Abbey

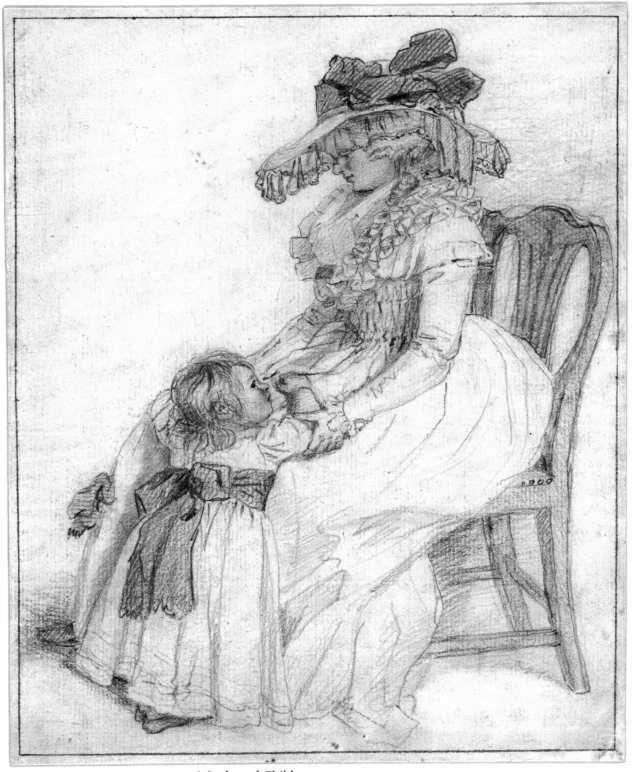

51. JOHN RAPHAEL SMITH: A Lady and Child

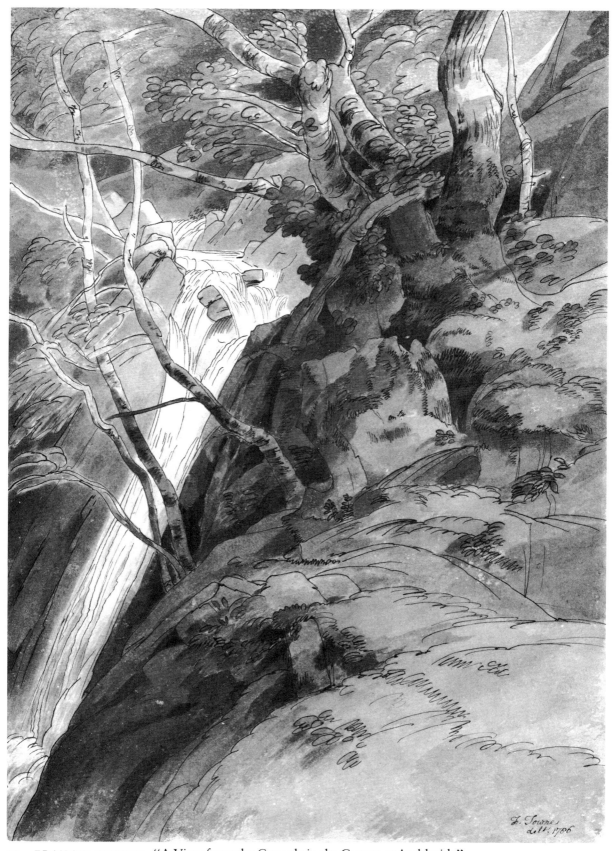

52. FRANCIS TOWNE: "A View from the Cascade in the Groves at Ambleside"

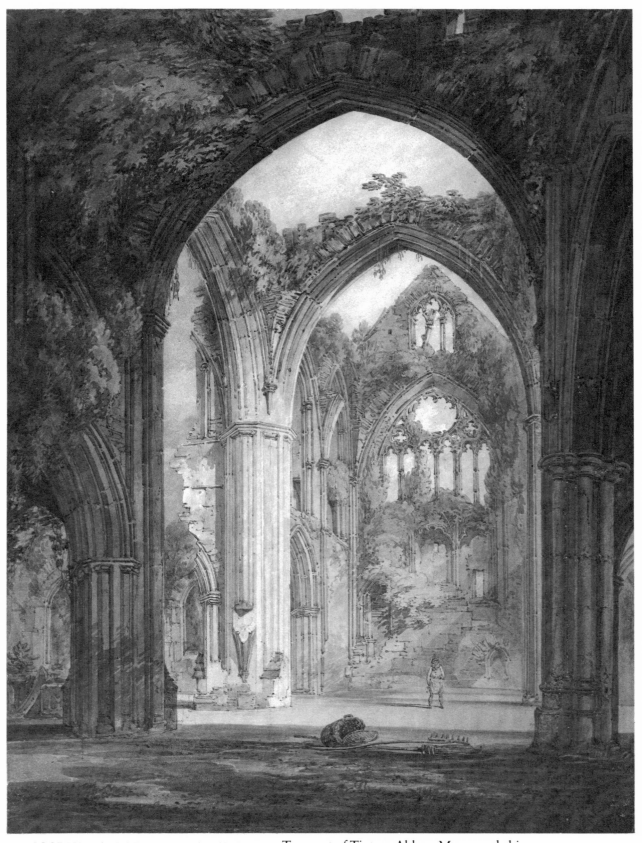

53. JOSEPH MALLORD WILLIAM TURNER: Transept of Tintern Abbey, Monmouthshire

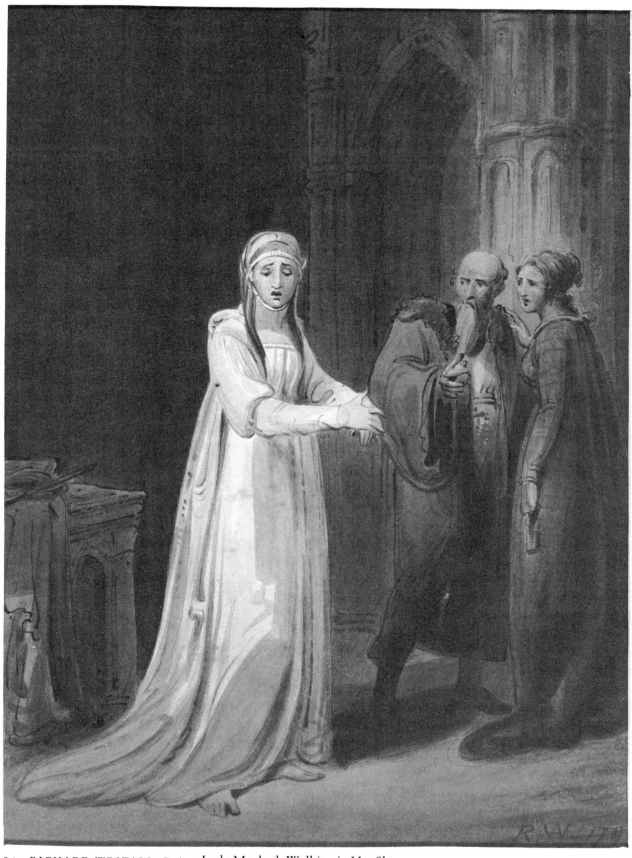

54. RICHARD WESTALL, R.A.: Lady Macbeth Walking in Her Sleep

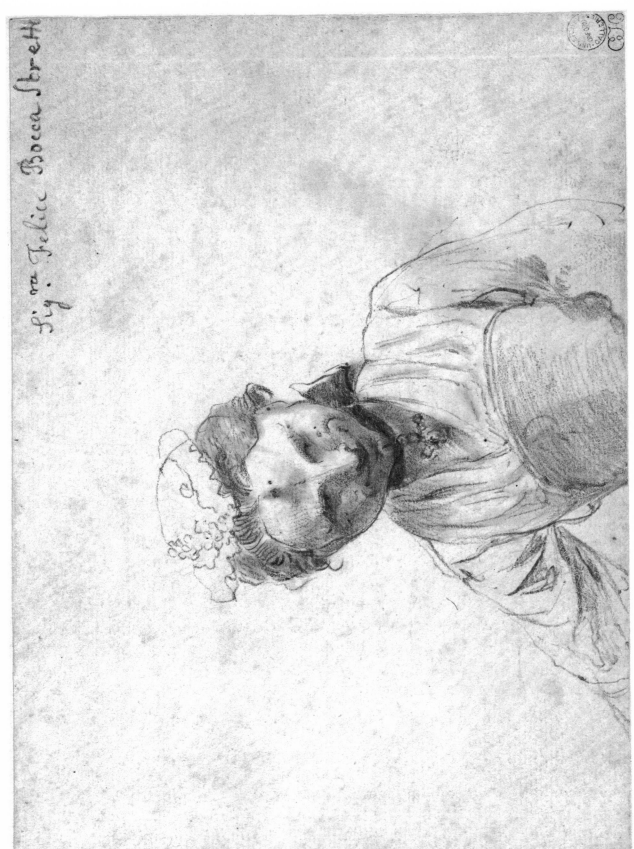

Sig.ra Felice Bocca Stretto

55. RICHARD WILSON, R.A.: "Signora Felice Bocca Stretto"

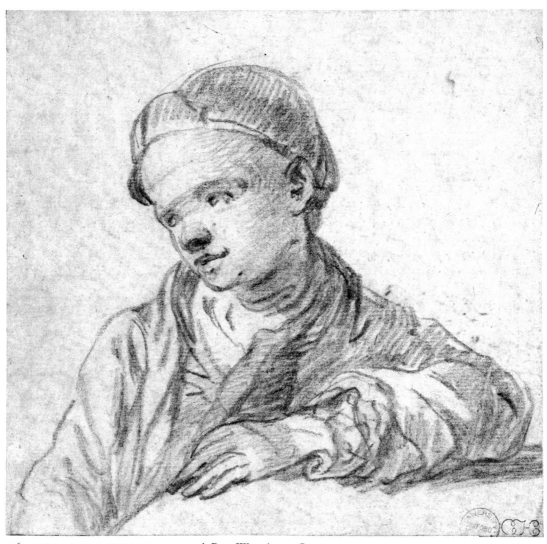

56. RICHARD WILSON, R.A.: A Boy Wearing a Cap

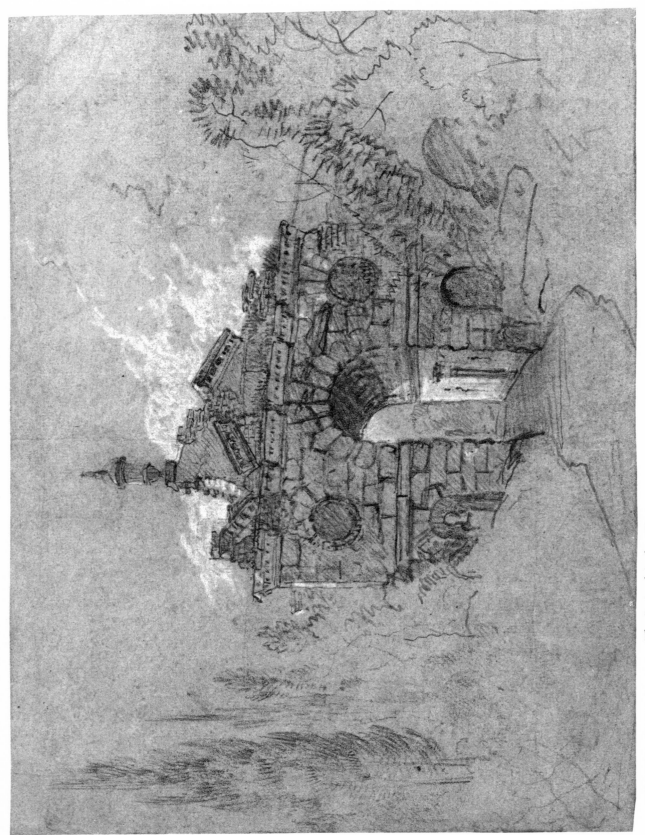

57. RICHARD WILSON, R.A.: The Ruined Arch at Kew

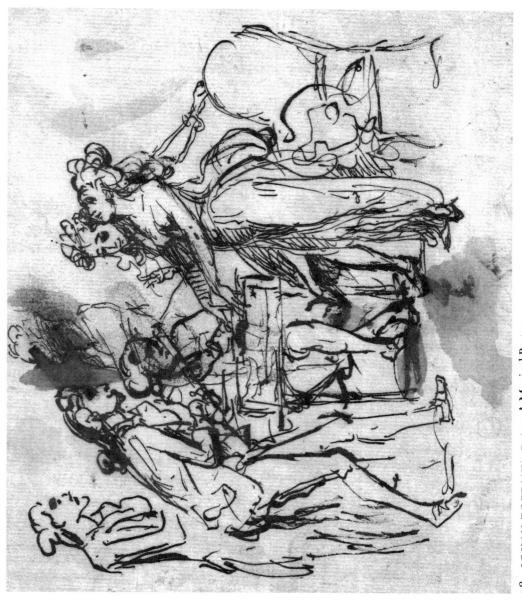

58. JOHAN ZOFFANY, R.A.: A Musical Party

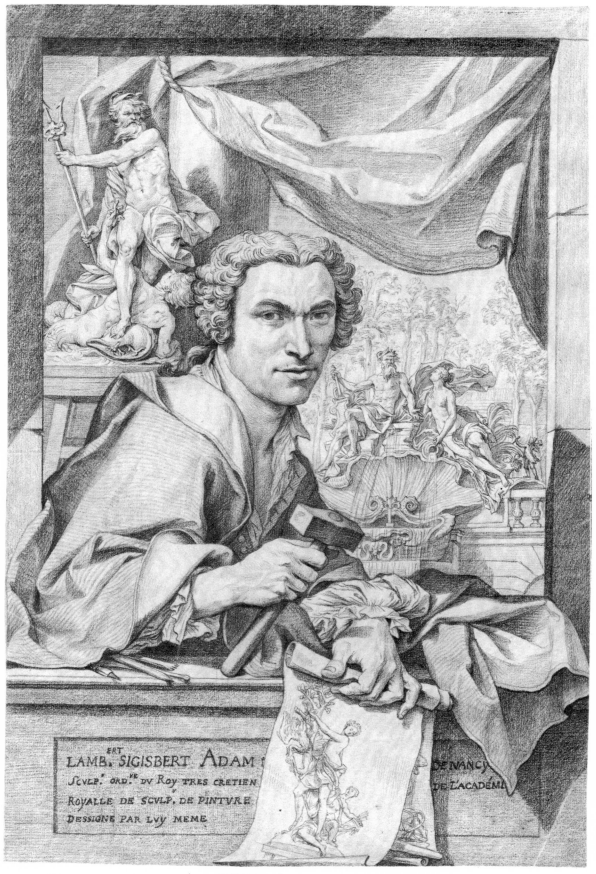

59. LAMBERT SIGISBERT ADAM: Self-Portrait

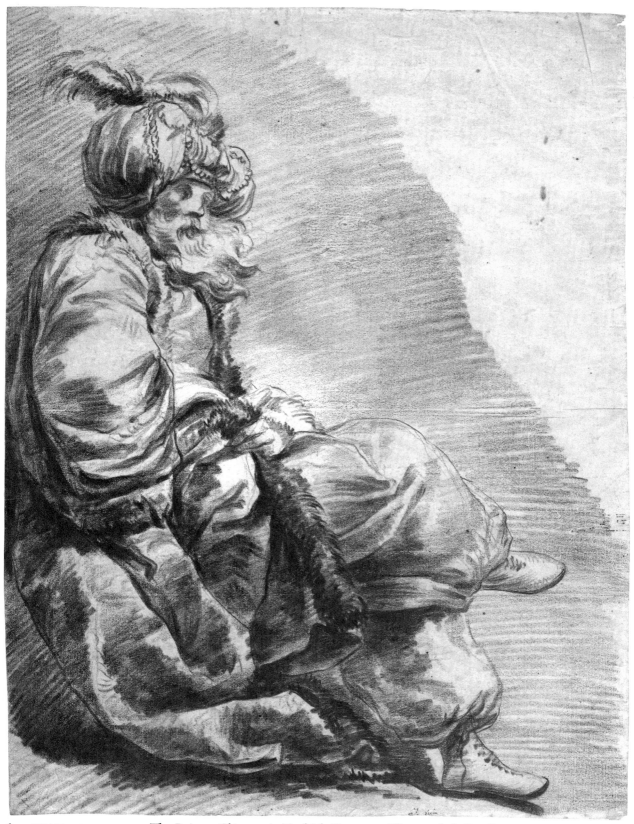

60. JEAN BARBAULT: The Painter Clément in Turkish Costume: "Prestre de la Loy"

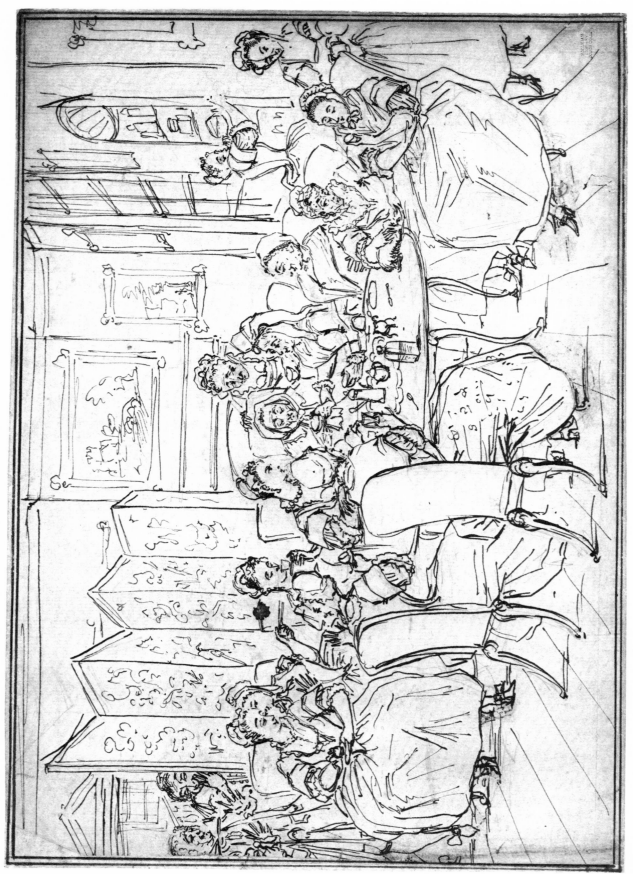

61. LOUIS-PHILIPPE BOITARD: A Tea Party

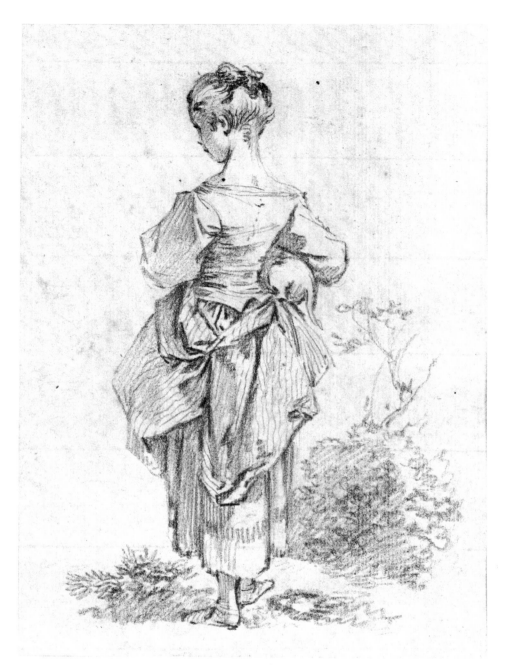

62. FRANÇOIS BOUCHER: A Young Girl Carrying a Dog

63. FRANÇOIS BOUCHER: Mars and Venus

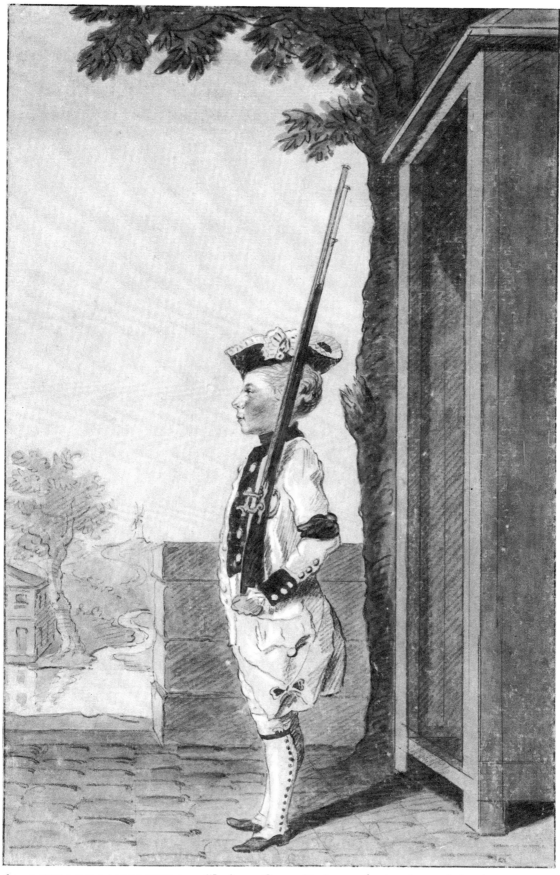

64. LOUIS DE CARMONTELLE: "Le jeune Comte Du Lau en faction devant le Logis de Son Père"

65. CHARLES-NICOLAS COCHIN THE YOUNGER: "La Soirée"

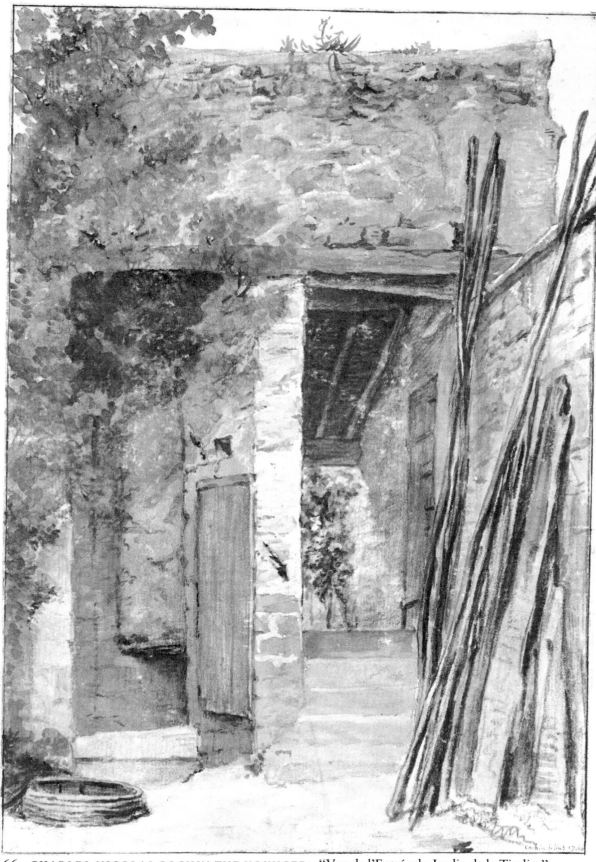

66. CHARLES-NICOLAS COCHIN THE YOUNGER: "Vue de l'Entrée du Jardin de la Tirelire"

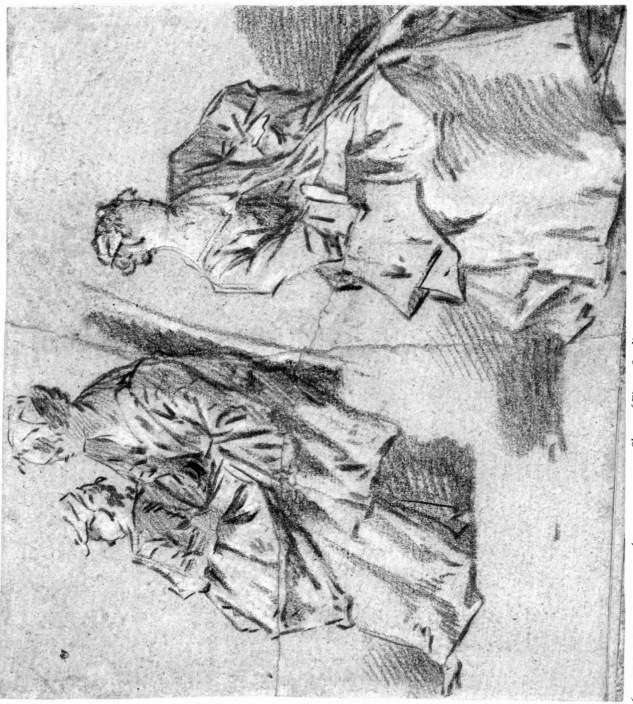

67. JEAN-BAPTISTE-SIMÉON CHARDIN: Sheet of Figure Studies

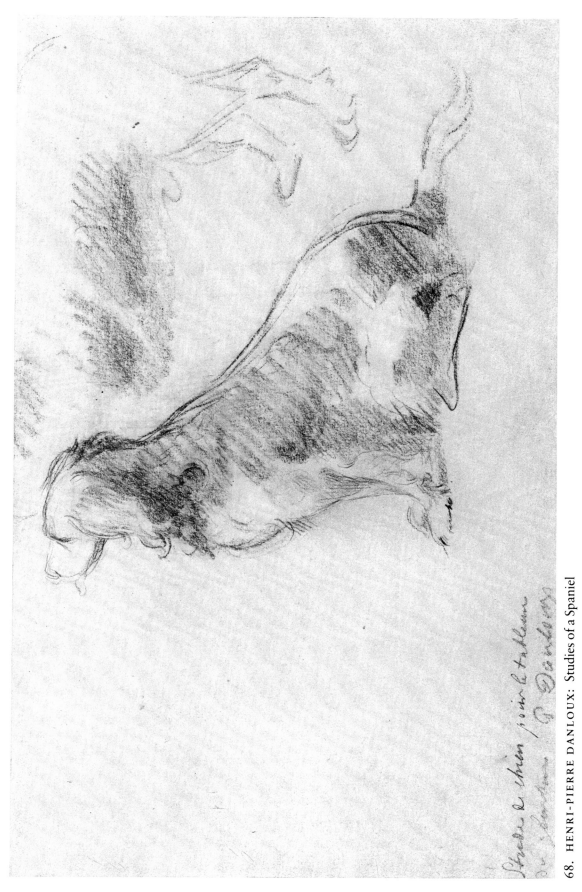

68. HENRI-PIERRE DANLOUX: Studies of a Spaniel

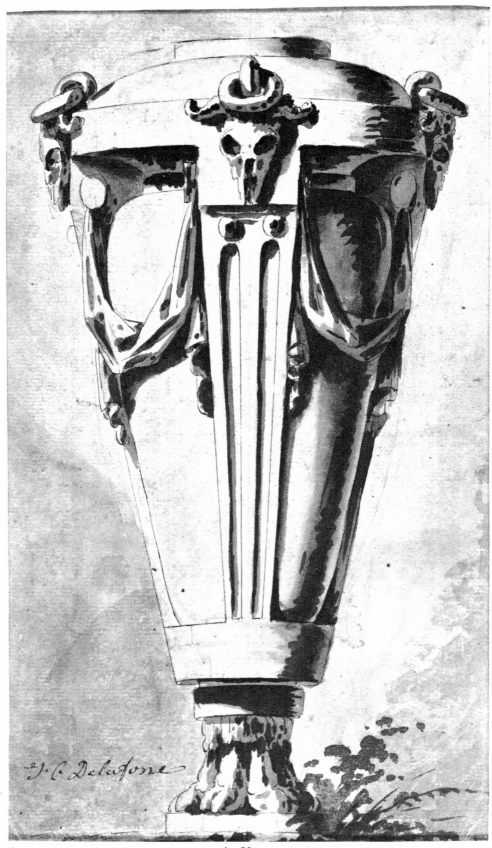

69. JEAN CHARLES DELAFOSSE: An Urn

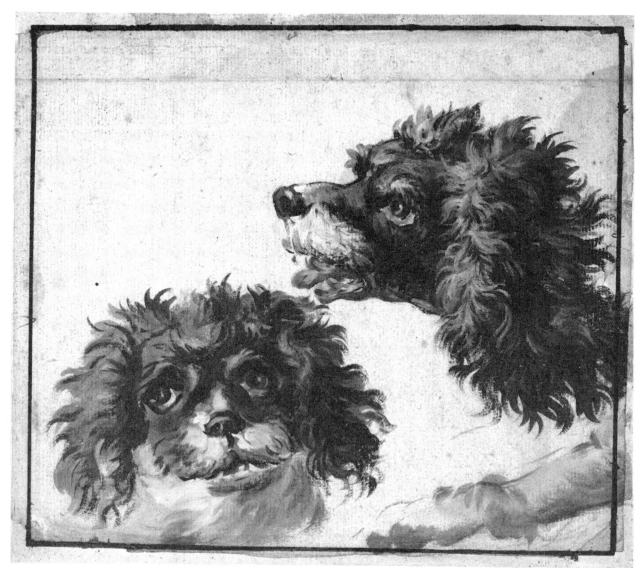

70. ALEXANDRE-FRANÇOIS DESPORTES: Studies of a Dog

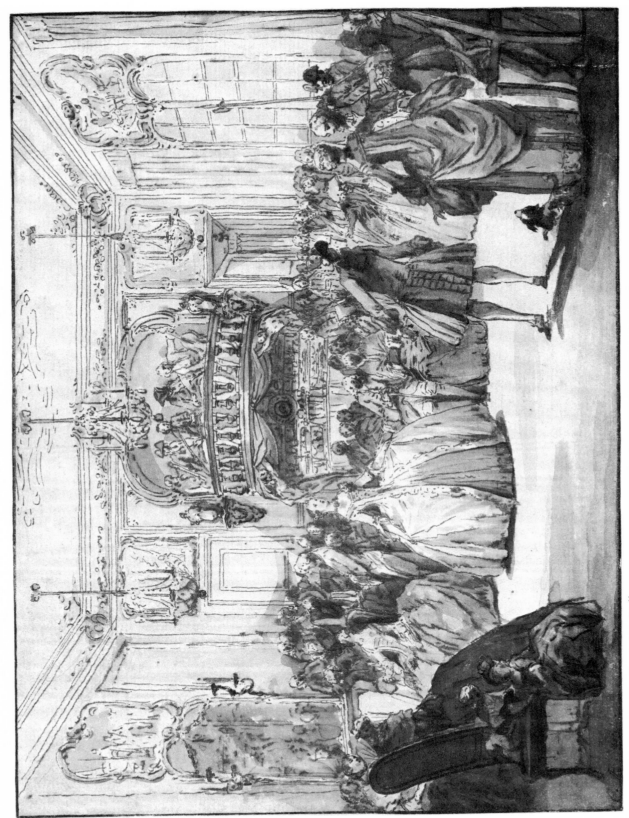

71. CHARLES EISEN: Scene in a Ballroom

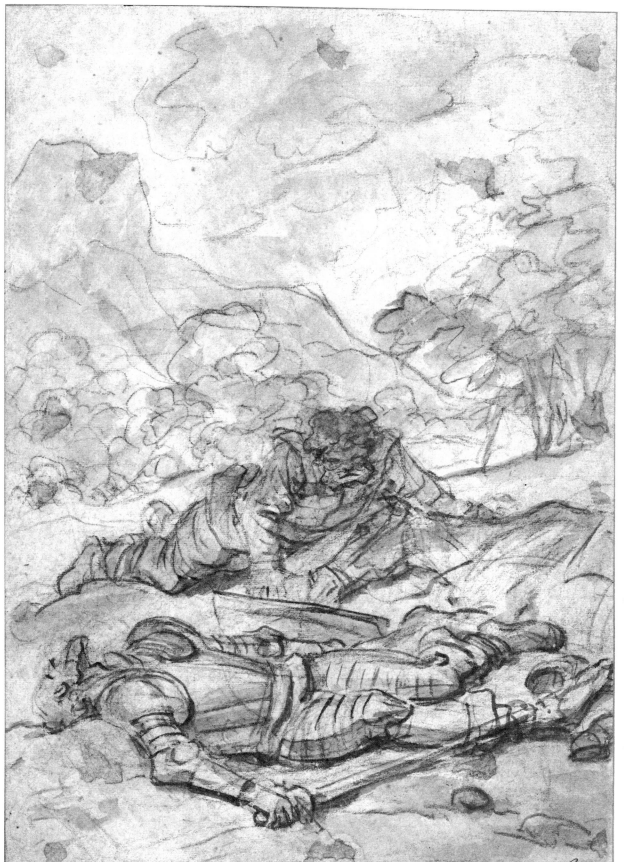

72. JEAN-HONORÉ FRAGONARD: A Scene from "Don Quixote"

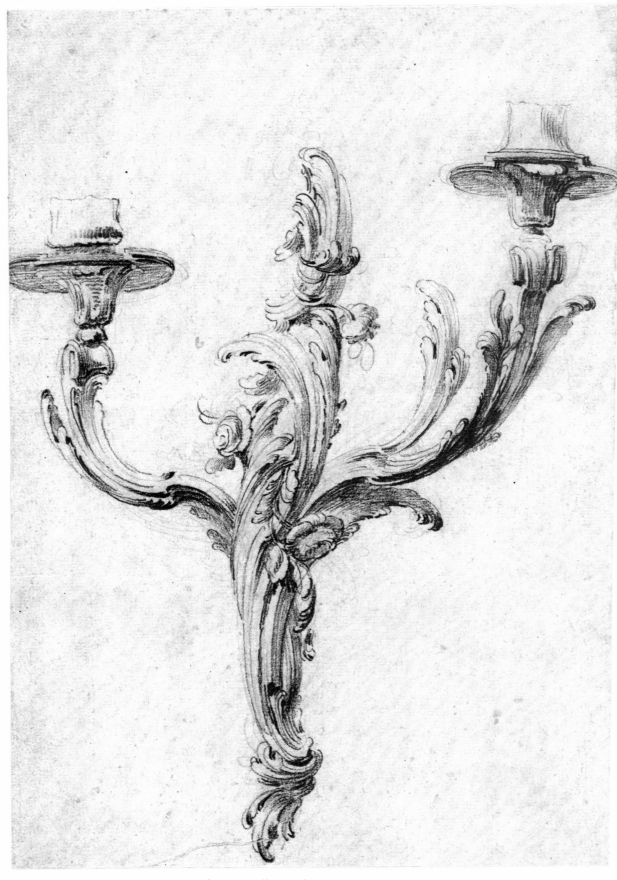

73. ROMAIN GIRAUD: Design for a Candle Bracket

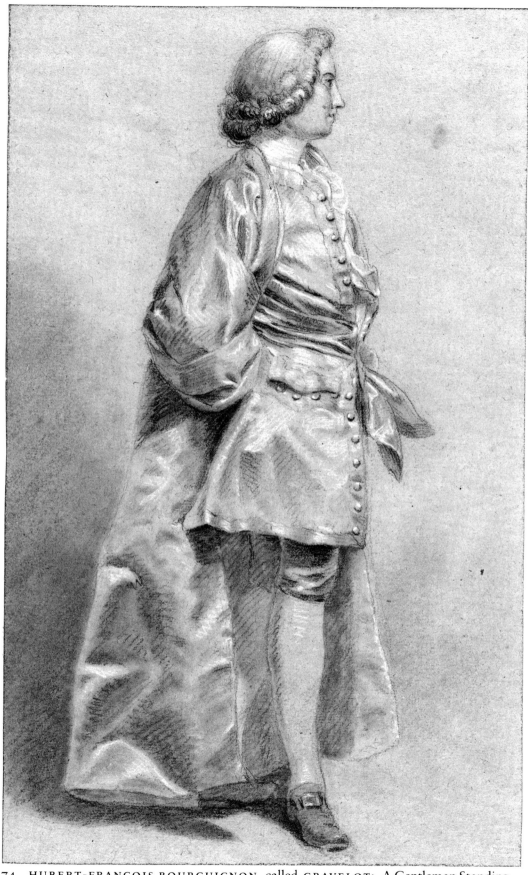

74. HUBERT-FRANÇOIS BOURGUIGNON, called GRAVELOT: A Gentleman Standing

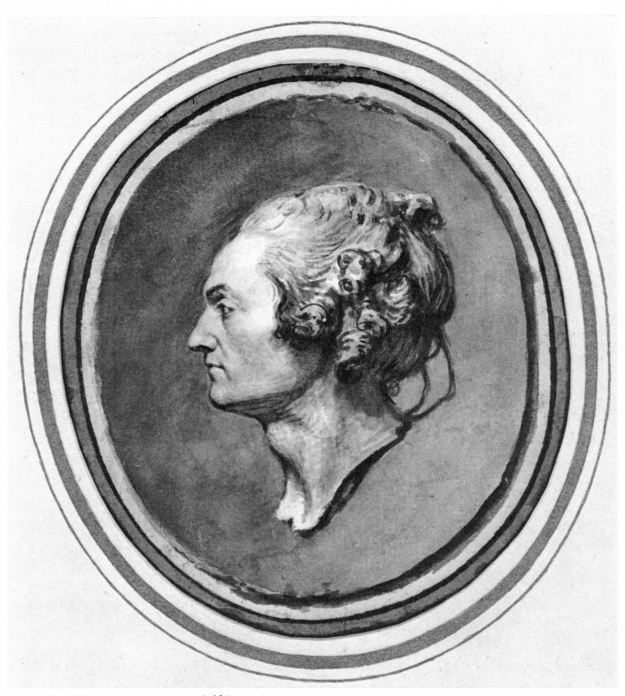

75. JEAN-BAPTISTE GREUZE: Self-Portrait

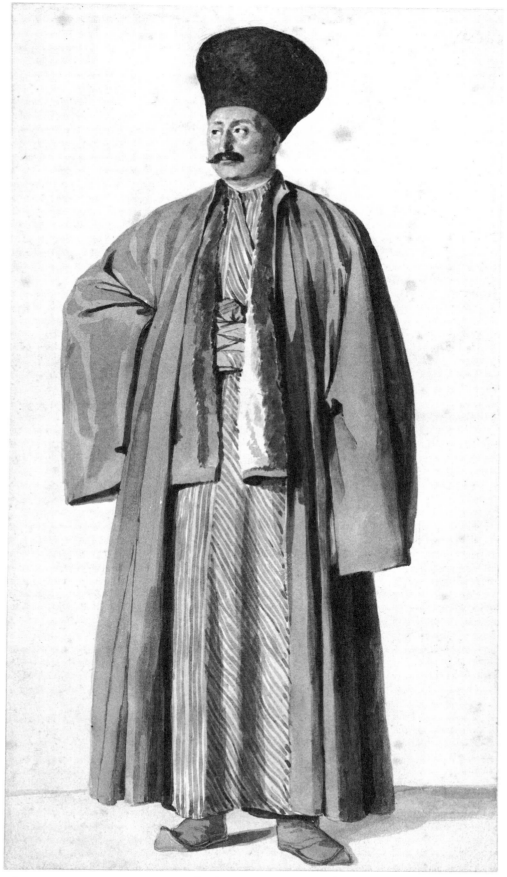

76. JEAN-BAPTISTE HILAIR: An Armenian in National Dress

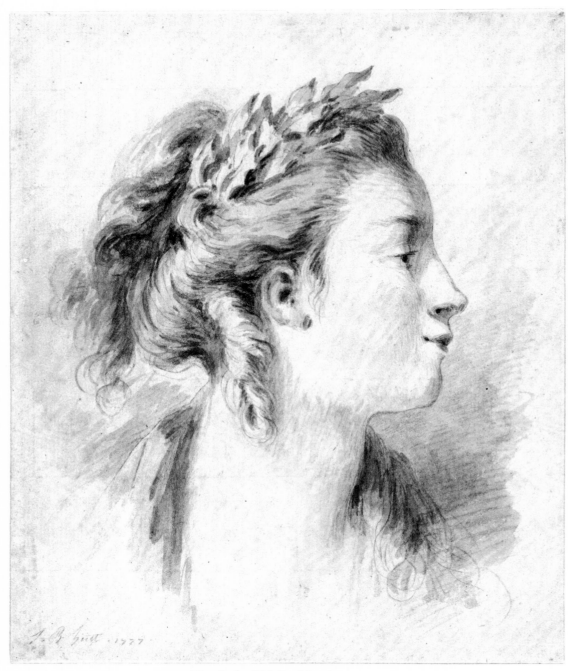

77. JEAN-BAPTISTE HUET: Head of a Girl (? a Muse)

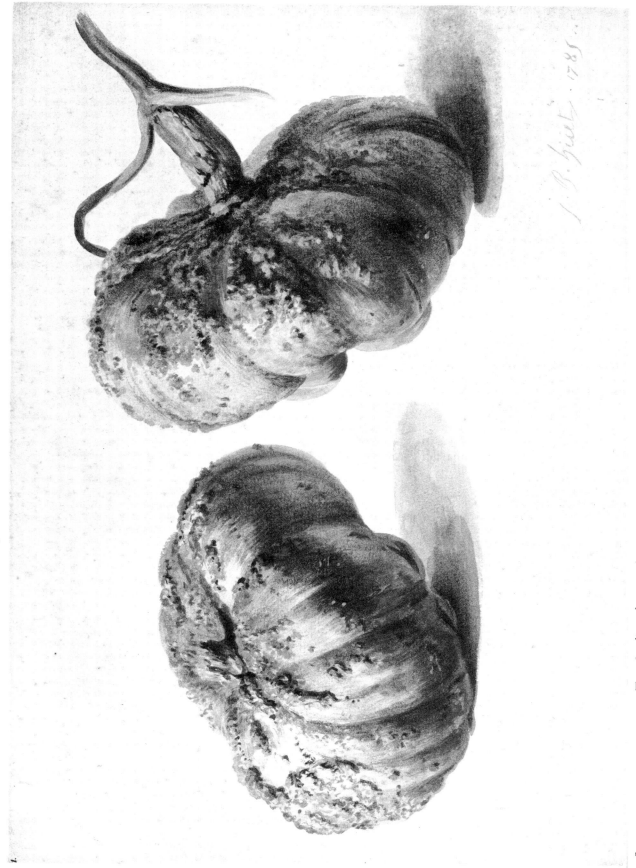

78. JEAN-BAPTISTE HUET: Two Studies of a Pumpkin

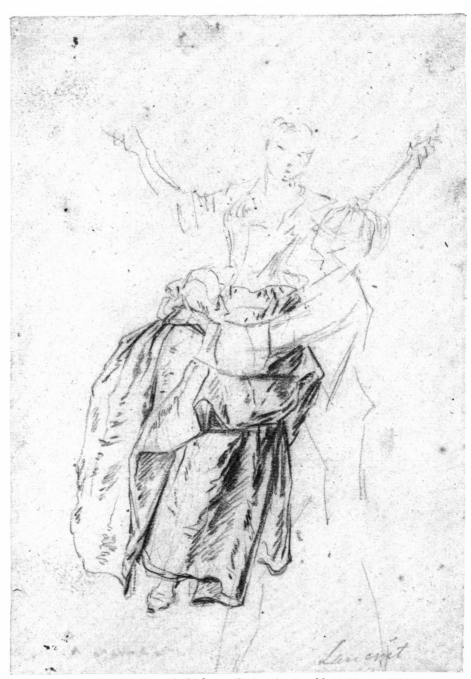

79. NICOLAS LANCRET: A Girl on a Swing Assisted by a Young Man

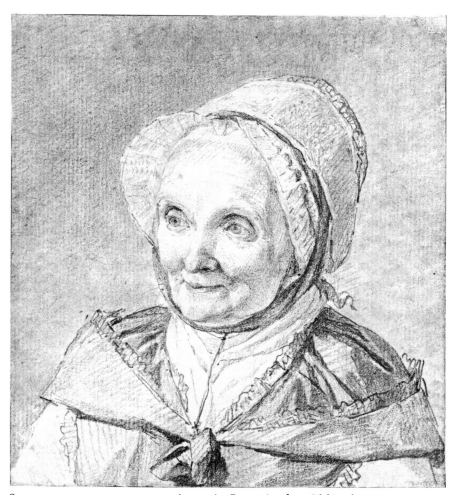

80. NICOLAS-BERNARD LÉPICIÉ: Portrait of an Old Lady

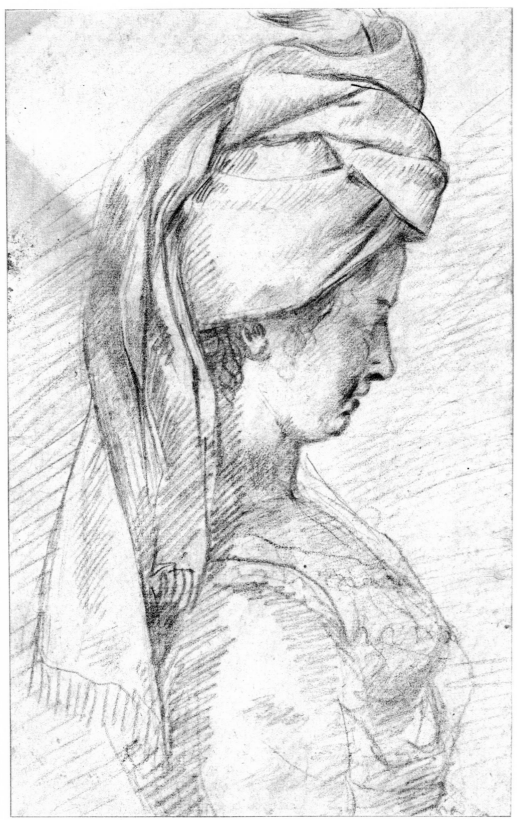

81. JEAN-ETIENNE LIOTARD: Study of a Woman in Profile to Right

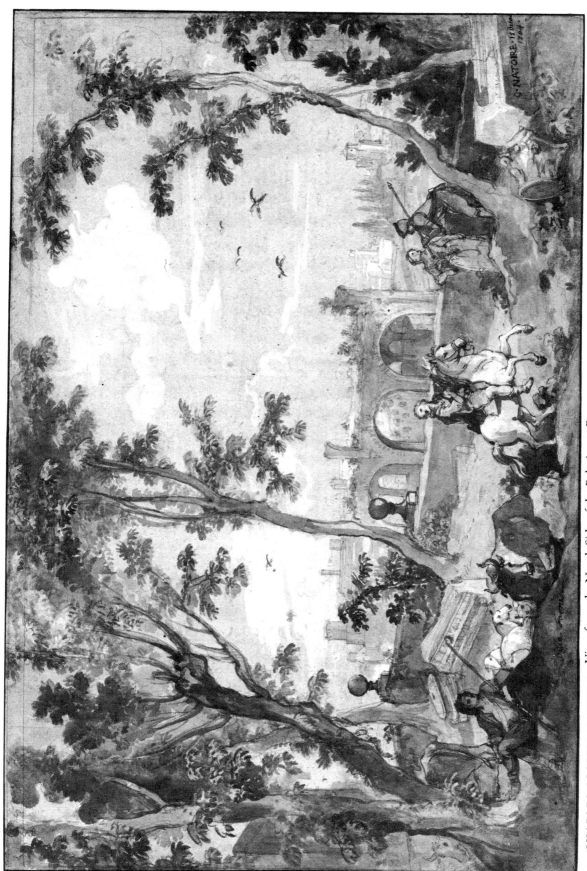

82. CHARLES-JOSEPH NATOIRE: View from the North Side of the Palatine at Rome

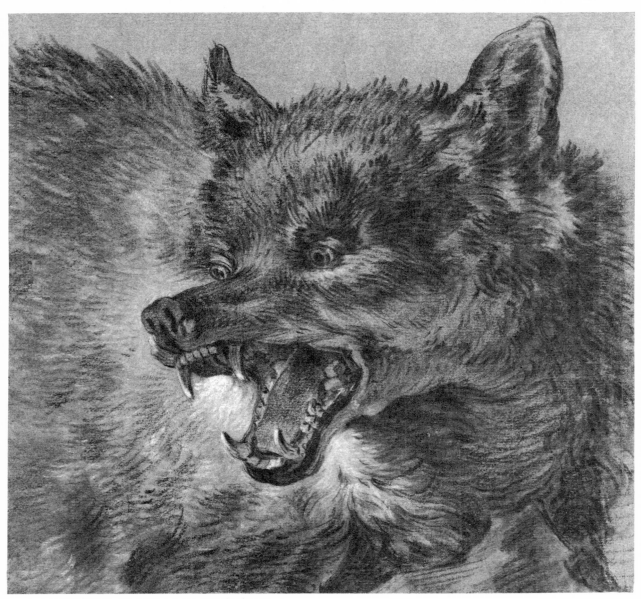

83. JEAN-BAPTISTE OUDRY: Head of a Fox

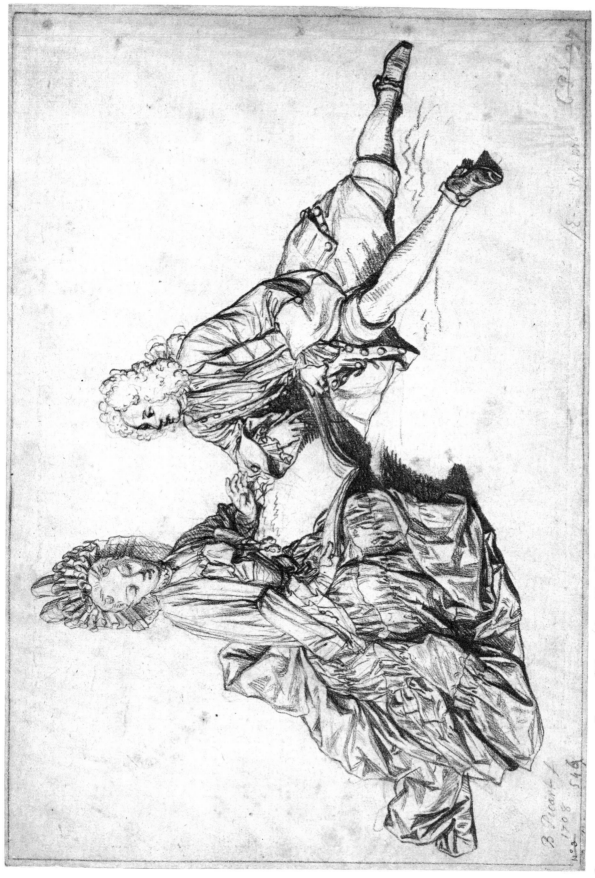

84. BERNARD PICART: Group of Figures for a Fête Galante

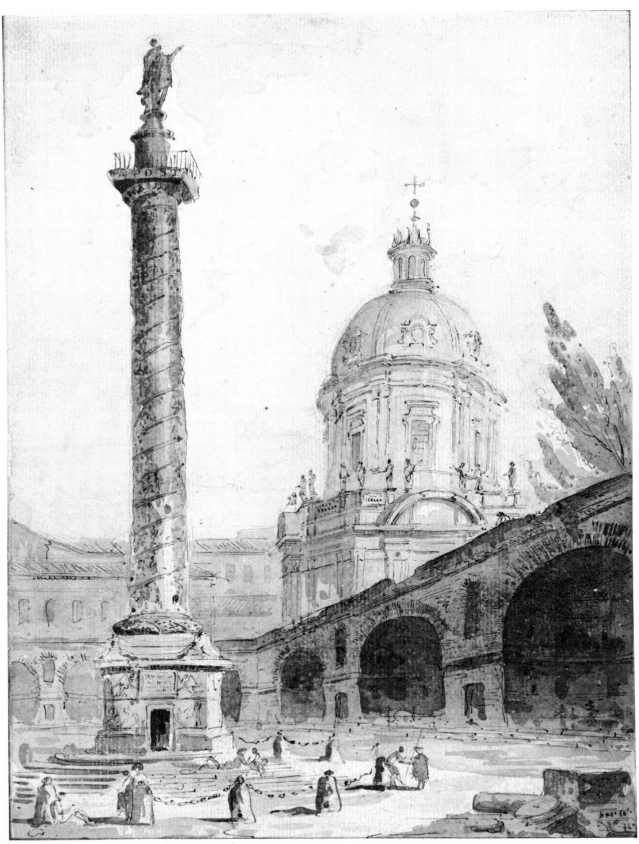

85. HUBERT ROBERT: The Forum of Trajan, Rome

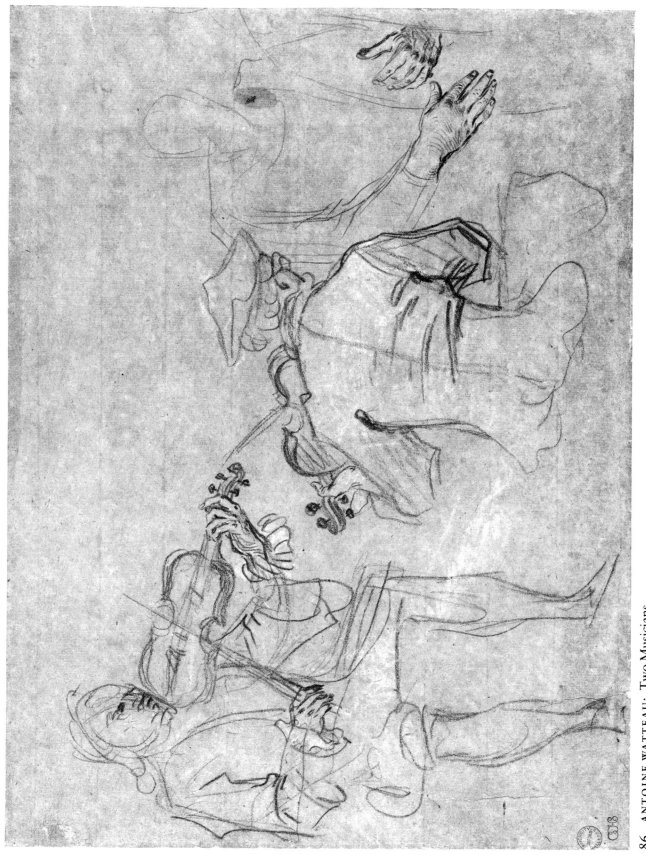

86. ANTOINE WATTEAU: Two Musicians

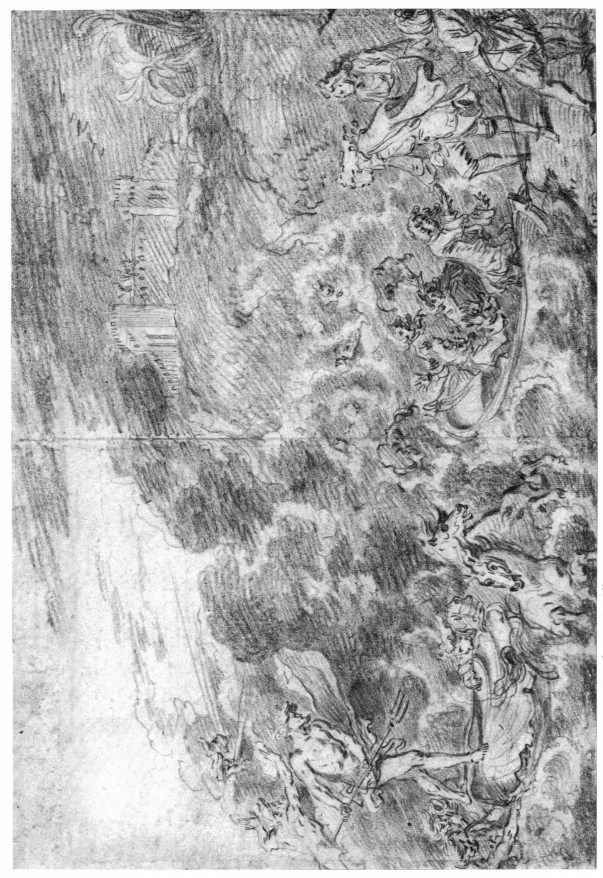

87. ANTOINE WATTEAU: "Le Naufrage": An Allegory

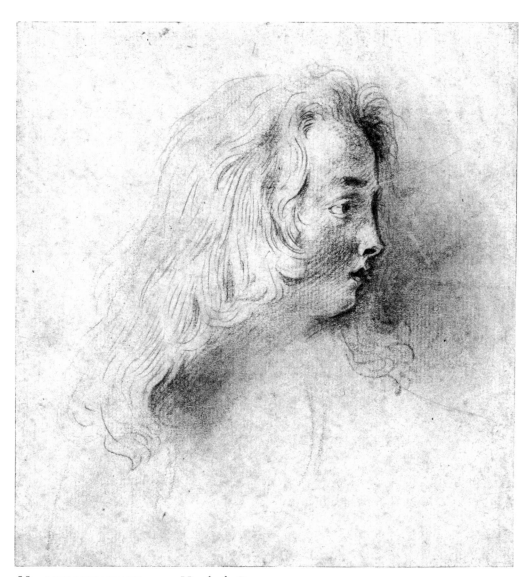

88. ANTOINE WATTEAU: Head of a Boy

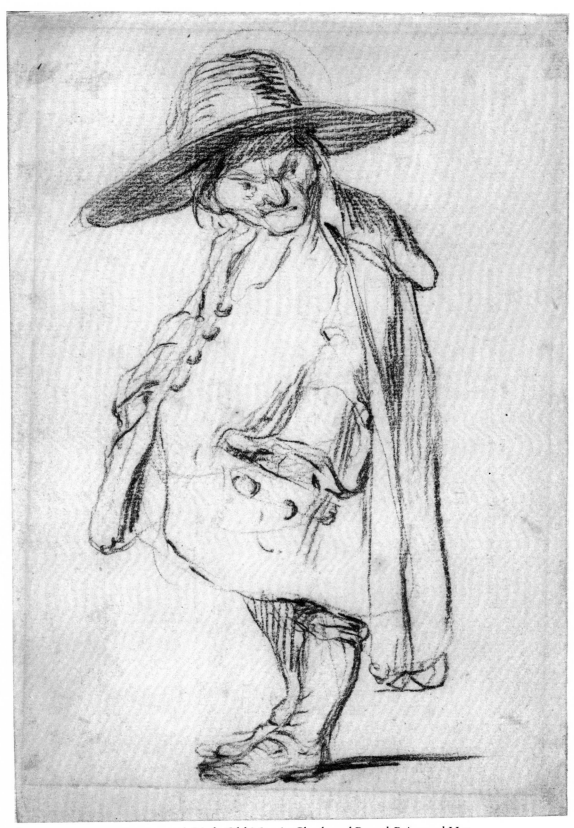

89. ANTOINE WATTEAU: A Little Old Man in Cloak and Broad-Brimmed Hat